Take Art

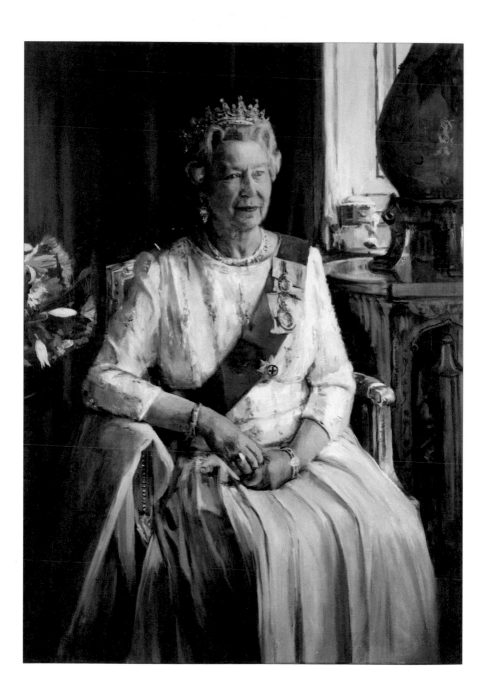

CHRISTIAN FURR

Take Art

EVEN IF YOU HAVE
FAILED BEFORE,
READ THIS BOOK
AND YOU'LL BE ABLE
TO DRAW IN A
MATTER OF HOURS!

JB
JOHN BLAKE

Published by John Blake Publishing Ltd,
3, Bramber Court, 2 Bramber Road,
London W14 9PB, England

www.blake.co.uk

First published in hardback in 2005
This edition published in paperback in 2008

ISBN 978-1-84454-627-5

British Library Cataloguing-in-Publication Data:

A catalogue record for this book is available
from the British Library.

Design by www.envydesign.co.uk

Printed in Vivapress, Barcelona

1 3 5 7 9 10 8 6 4 2

Papers used by John Blake Publishing are
natural, recyclable products made from wood
grown in sustainable forests. The manufacturing
processes conform to the environmental
regulations of the country of origin.

For Emma, Colette, Daphne and Anika

Acknowledgements

Emma, Colette, Daphne and Anika; John and Diane Blake;
Peter and Angela Furr for their early support; Mary Davies;
Ged Adamson; Colin McEvoy; Lee Wilson Wolfe;
Steve Cope; Wayne Sleep; Graeme Andrew; Michelle Signore;
Adam Parfitt; Annie Capstick; Richard Madeley and Judy Finnegan;
Amanda Ross; David Lee; Eros Tang;
Alan Matthews and all the artists!

Contents

Foreword by
Richard Madeley and
Judy Finnigan

We are not afraid to admit that we are a long way from being art experts. We know we like it, and we know we'd like to be able to do it, but like most people we have absolutely no idea about where to start. Art often seemed to us to be difficult and inaccessible, the domain of an elite few who have some sort of 'secret' knowledge that most of us will never share.

Christian, with his unshakable belief that *absolutely anyone* can be an artist, made us both realise that this is not the case. He can take whatever happens to be to hand – a pen, a pencil, a piece of chalk or a brush – and within minutes produce practically anything he wants to. But he has also developed a fantastic way of teaching even the most unskilled artists how to do exactly the same. He has the uncanny ability to make the seemingly difficult perfectly easy, and has made us understand that the joy of being an artist is completely within our grasp.

And we're not alone. When Christian appeared on our show teaching celebrities how to draw and paint, people contacted us in their thousands wanting to know more, and as a result we even launched a campaign to find the country's best amateur artists. The response was overwhelming: clearly, Christian has tapped into something that many of us feel – a desire to express ourselves in this way if only we knew how to.

This brilliant book will teach you just that – simply and step by step. What makes it so appealing is that it is completely down to earth: it won't tell you *what* you should draw, just how to draw what you want. So, if you'd like to imitate Picasso, it will teach you how; but if all you've ever wanted to do is draw David Beckham, then fine – it tells you how to do that too.

Christian's quiet, friendly manner will give you the encouragement you need to create whatever you want to create – and believe us, if it can work for us, it can most certainly work for you! Thank you, Christian, for showing us that art can be fun and not stuffy, and that we all have it in us to be an artist.

Richard Madeley and Judy Finnigan

Introduction

*'Every child is an artist. The problem is how
to remain an artist once he grows up.'*
PABLO PICASSO

A couple of generations ago, everybody could paint and draw. In the Victorian era my great-grandfather used to take a sketchbook with him everywhere he went. Now, because of the way art is taught in schools, this skill has been lost. Figurative work is frowned upon in some quarters as passé. I mentioned watercolours to somebody the other day and they wrinkled their nose up at me and made a disparaging remark. It made me angry. Picasso could draw beautifully before he pushed the human form to its most unrecognisable. His knowledge was grounded in the basics. In days gone by, artists received apprenticeships and learned to draw like it was a craft. Now it seems artists don't *want* people to understand their work. They want to confound because they think it's clever. People are told they can't draw or paint, but I believe everybody has the ability. You can't learn about something without *wanting* to learn about it. The fact that you have bought this book, however, means you have an interest and are committed to learning how to draw. You want to do it, so congratulations!

If you have received negative criticism in the past about your artistic abilities, I want you to put this in the past and come on a journey of discovery with me. I am going to be your guide as we uncover the secret of the lost art.

HANDY HINTS

Where you see this symbol it means it's time for a handy hint.

ARTY FACTS

Where you see this symbol it means it's time for an arty fact.

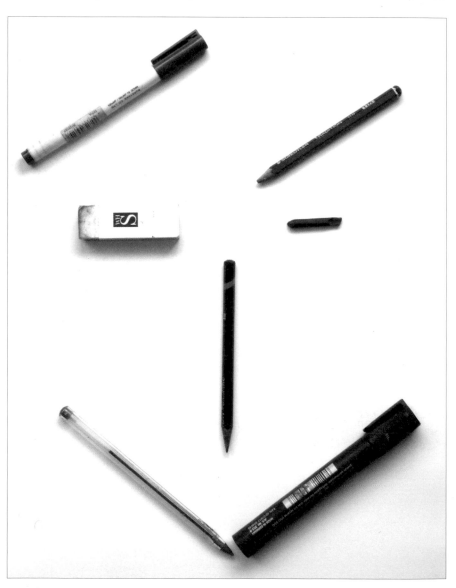

YOU CAN DRAW WITH ANYTHING

Forget what art shops or some art books tell you about having the right art materials to get the right 'technique'. Technique schmechnique: you can draw with anything that's to hand – a biro, a pencil, a crayon, a piece of charcoal, even an eraser (I'll show you how later) – anything that makes marks. Cavemen weren't fussy and they produced beautiful drawings and paintings of instantly recognisable things that have lasted for centuries using the most basic of tools. So, if they weren't fussy, why should we be?

HANDY HINT

2B OR NOT 2B?

Ever wondered what the numbers mean on pencils? They refer to the graphite in them and how hard or soft they are. HB is the standard pencil type. 9H is the hardest (lightest) and 9B is the softest (darkest). I would recommend a 2B for the exercises in this book as it's a good all-rounder, but have a look at the chart below to get an idea of just how many pencil shades are actually available!

darker **lighter**
9B 8B 7B 6B 5B 4B 3B 2B B HB F H 2H 3H 4H 5H 6H 7H 8H 9H

YOU CAN DRAW ANYWHERE

You can draw anywhere on anything (law permitting).

ARTY FACT

Did you know that when Van Gogh was starting out as an artist he bought a 'how to draw' book with pictures in it and drew them over and over again? The book was called *Cour de Dessins* by Charles Bargue and Jean-Leon Gerome. Even Picasso trained from the book! Van Gogh only spent the last ten years of his life making art, and the first two were spent learning to draw. He started when he was twenty-seven in 1880. If you compare any drawings from this year with drawings from 1882, the difference is profound. He went from somebody struggling with proportion to becoming an excellent draughtsman. It goes to prove that these skills can be learned.

YOU CAN DRAW ANYTHING

You can draw anything you like, whether it's intricate landscapes or simple little doodles. I always remember visiting the Medici Chapel in Florence and looking at a wonderful large drawing by Michelangelo. My eye gradually came to the margin of the drawing and there, in all its glory, was a funny doodle of a man's face.

So doodling is drawing too. Before we begin the next few exercises, pick up a pen or pencil and have a doodle. Draw some squiggles. Draw a flower or a house. Drawing is fun. It is not a task. It is about play and, as Einstein is supposed to have said, 'Man's greatest intellectual leaps are made in the mood of play.' You don't

5

learn about something through succeeding at it; you learn through failing at it and persisting with it. That's why I tell people, don't scrunch! When people in my classes scrunch up their paper through frustration, I get annoyed. You have to stick with something and see where you are going wrong to get the best results. You will be surprised how something you think is awful becomes fantastic if you carry on with it regardless. You can always use the rubber or rag to rub out, but it really helps to have your previous guide lines there in front of you. You only have to look at X-rays of the great art of the past to see where the artist has painted something wrong then corrected their mistakes. Art and drawing is about trial and error, and making marks that are not always right is part of the process.

Do you know how old Colonel Sanders of Kentucky Fried Chicken fame was when he hit the big time? Sixty-six! At sixty-six, he lost his business and began to live on social security. He realised he couldn't carry on like that and went round the country trying to sell his recipe for fried chicken. He was turned down an amazing 1,009 times before someone said yes and he went on to become a multimillionaire. Art and business don't normally mix – they are like oil and vinegar, as Turner once said. But this is one case where you can apply the rules of business to your art: you have to be brave, tenacious and not afraid to make mistakes.

Make a mark then worry about it later. Very rarely does anybody get it right first time, and it's better to have

> **HANDY HINT**
>
> When medieval monks got bored of doing their weighty illuminated manuscripts they would doodle in the margins. These doodles are known as 'babooneries'!

ARTY FACT

Picasso was fond of drawing on napkins at some of the restaurants he visited. One day he was sitting at a table in a small Parisian café. A well-dressed woman approached and asked if he could draw a sketch of her on a napkin. 'You can charge whatever you want,' she said.

Picasso asked a waiter for two napkins. He pulled out his pen and drew a picture on the first napkin. On the second he wrote the astronomical price for the drawing. The woman gasped. 'Why is it so expensive? It only took you a few minutes to draw the sketch.'

Picasso thought for a moment, and replied, 'It took me a lifetime to learn how to draw that sketch.'

something on the paper than nothing. The glaring white of a piece of paper scares some people away, so dirty it up with some marks and you won't be scared any more. Remember this with our initial exercises. Draw loosely and lightly – you can make the line darker later on. These are only exercises, and it's only paper …

Have a look at the image below by Leonardo. Look how many times he has drawn over the rider's head and horse's front legs, to try and find the right position.

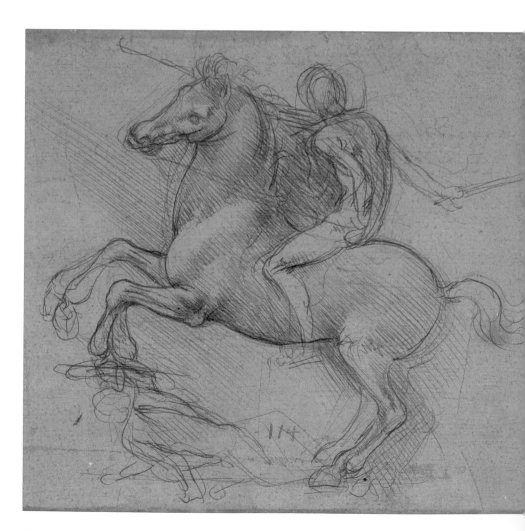

DON'T BE AFRAID TO MAKE MISTAKES

'I tell you, if you want to be active, you must not
be afraid of failures, and you must not be afraid
of making mistakes.'

VAN GOGH

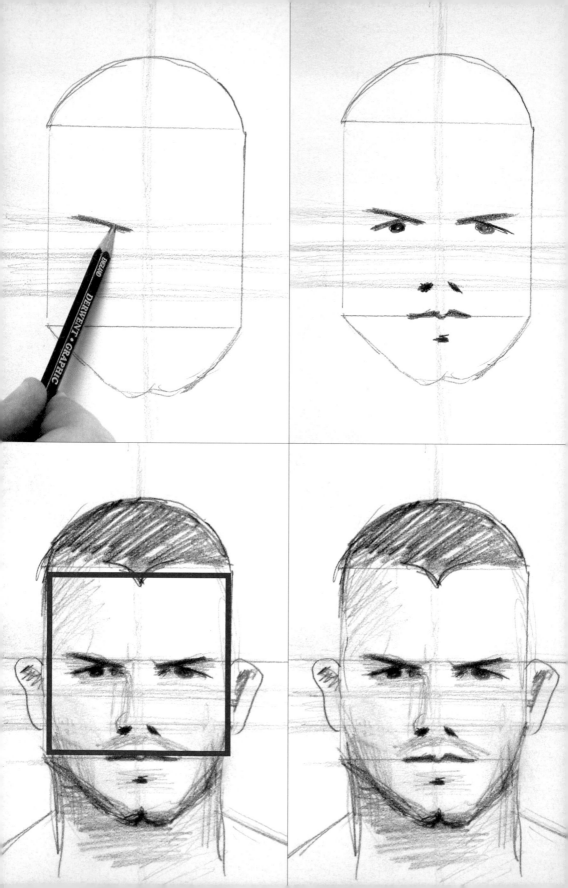

1

Shapes of things

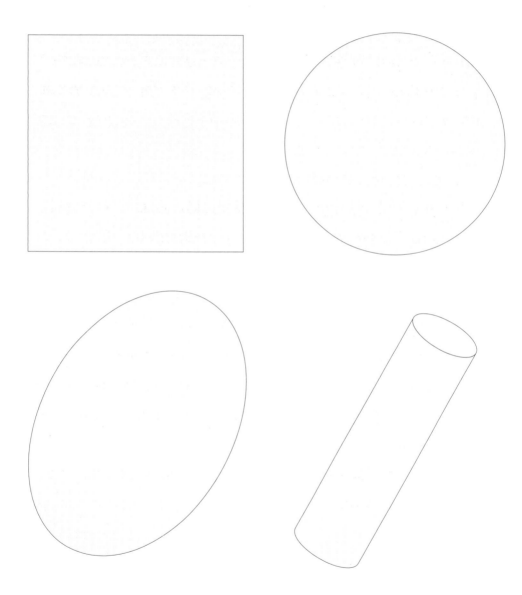

SHAPES OF THINGS

To start off with, forget about detail. We are looking at the big picture, not the small one. Everything in life is made up of – or can be broken down into – basic shapes. When you are drawing or painting anything, it is important to get its proportions right first. We can do this by looking at its basic shape.

Opposite, you'll see some shapes.

Have a look around you. You should see some shapes. If you're inside you may see a rectangular door or a square wall. All very well, you may think, but what about, say, people? Surely they are more complex to draw than doors and walls. Well, not if you remember that *everything* can be broken down into shapes. These shapes can help you draw by helping you to see the form in an object or the way that a picture should be composed.

In the exercises that follow, we are going to use each one of these shapes to draw some things that everybody will recognise.

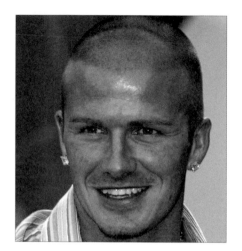

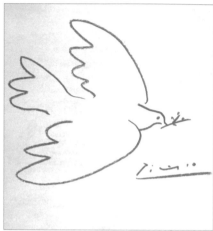

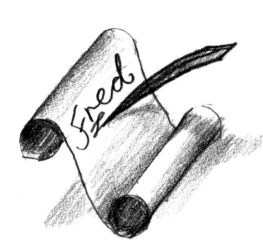

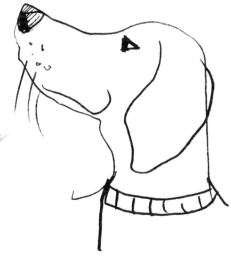

FOUR EASY EXERCISES

Opposite, you'll see some images of things you may be familiar with. To learn how to draw, we are going to use the shapes on the previous page to help us. Each exercise is broken down into four steps. Using things that you will be able to find at home or in the office, you are going to draw these familiar images – and hopefully realise that you *can* draw after all.

Each of these first four exercises is a taster for the things we are going to cover in the rest of the book. You may not get things exactly right first time, but don't worry – you can draw them as many times as you like. Don't forget that practice makes perfect.

Are you ready? Then grab a pencil and some paper and we'll begin.

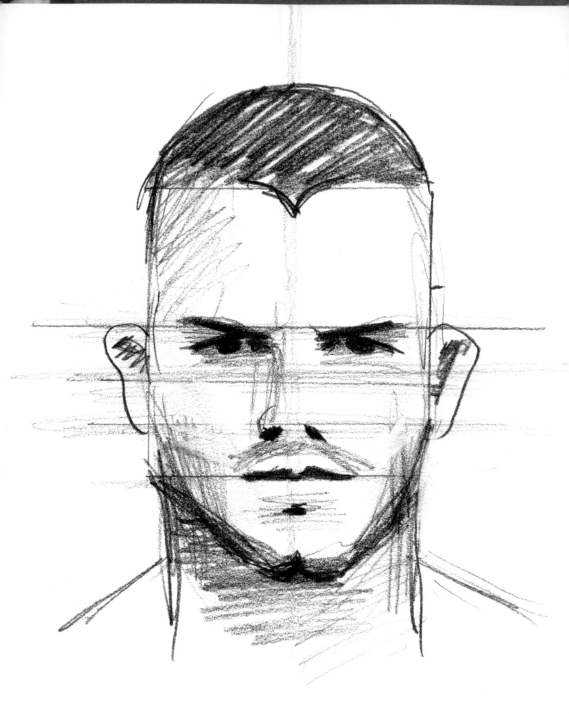

Exercise One: How to Draw David Beckham

People often ask me how they can get a good likeness. 'I couldn't do that!' they say. Hmm … well, is that really so? Getting a good likeness is all about getting the *proportion* of the face right. Take a look at the picture of David Beckham. He has a distinctive look, doesn't he? Is there anything you can see in this drawing – an overall shape visible in his face? Any ideas? Flick over to the next page to see the shape I am talking about …

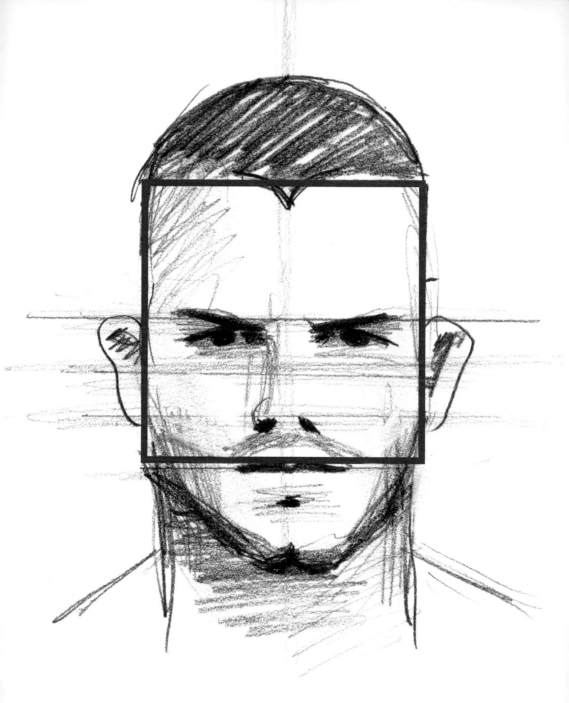

Voilà! David Beckham has a square-shaped face. So find something square and get your pencil and paper ...

Step one

Draw around something square. I used a block of repositional notes for this exercise. Place it in the middle of the paper so that you leave enough space around it for the rest of the face. You should be left with a roughly drawn square on your page like this:

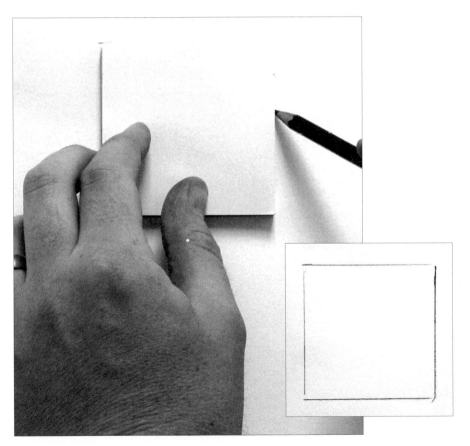

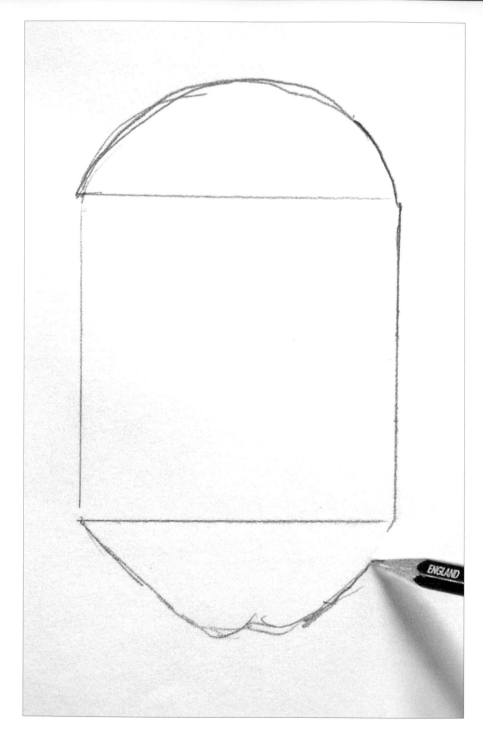

Let's draw the top of the head first. Starting from the left, with a nice broad stroke, draw a big arc over the top of the square. It should be about a third of the square's height, and should peak in the middle.

At the bottom of the square, starting from the left again, draw an arc that is symmetrical to the one at the top with a cleft in the middle. Do it roughly to start with – and remember that you are allowed to draw a line twice if you get it wrong! Again, it should be about a third of the square in depth.

Well done. You've drawn the top of the head and the chin.

HANDY HINT

As a rule, when drawing human heads front on, the eyes appear halfway down the head. When the head tilts up or down, this changes.

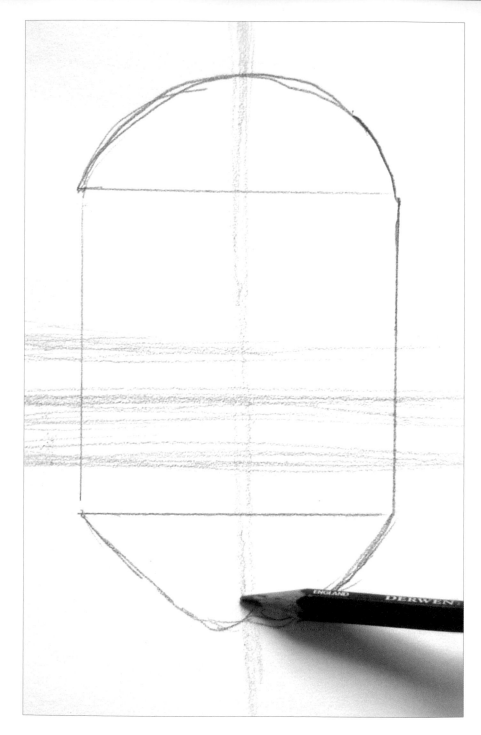

Step two

Now we need to establish the proportions of the rest of the face. Starting from the middle left of the square, cut the square in half across the face with a long, broad sweep of your pencil. This line is where the eyebrows are going to be.

Split the lower half of the square into three by drawing two horizontal lines. (You should now have three lines going across the lower half of the square.) Next, split the head in half vertically.

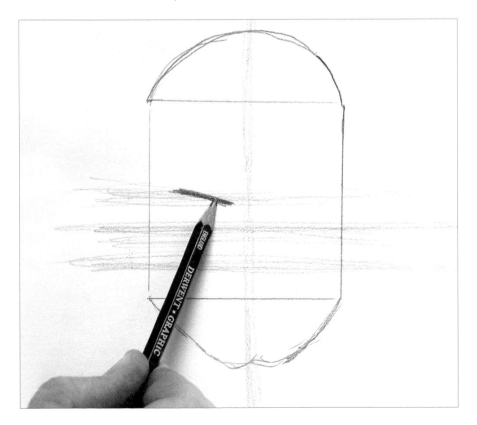

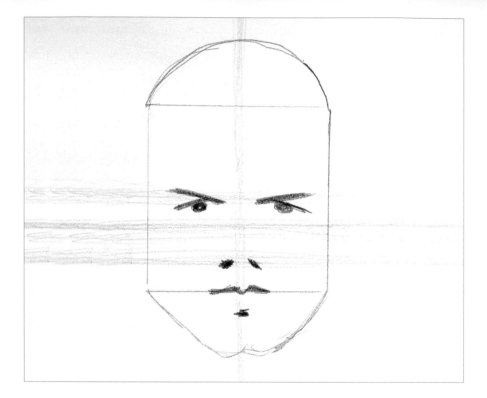

Step three

Now that we have the guide lines in place we are ready to draw in the features. On the left-hand side, on the halfway line, make a short slanted line downwards, as shown in the drawing on the previous page.

OK. We've drawn an eyebrow on the left. Mirror this on the right-hand side so the line slopes towards the middle and we have two eyebrows. David Beckham has a fairly symmetrical face, so we can mirror whatever we do to the left of his face on the right.

For the eyelids, on the left-hand side of the square draw

a short line under the eyebrow, sloping down to the left. It should be roughly in the middle of the half square. When it touches the eyebrow it should look like a >. Mirror the eyelid on the right-hand side of the square to get a <.

For the eyeballs, draw a dark circle on the left, directly underneath the eyelid and roughly in the middle of the half square. Repeat this on the right-hand side. You've drawn the eyes.

Now it's time to draw the nose. On the left-hand side of the square, on the third line down, make a short dash pointing upwards to the middle. Mirror this dash on the right-hand side. These are the nostrils. Make sure you leave a gap in the middle for where the bridge of the nose is.

We want to *suggest* the lips here, not draw their outline, so we draw the shadow of the top lip and the shadow below the lower lip. *We are drawing what we see, not what we know. Art is about leaving things out as much as it is about putting things in.* On the bottom line of the square we created originally, draw a heavier line across starting roughly underneath the left eyeball and finishing roughly under the right eyeball. Add two shallow mountain shapes on either side of the vertical guide line down the middle. Underneath this mouth line, make a short mark to suggest the shadow of the lower lip.

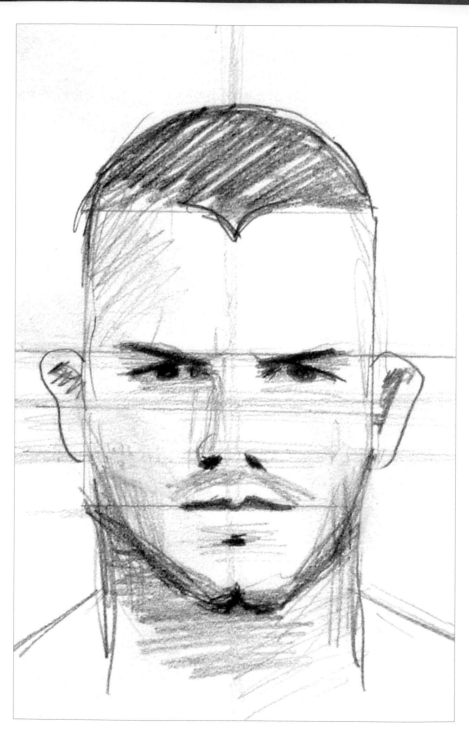

Step four

Now for the finishing touches. Let's add some ears. Draw an ear-shaped semicircle starting at the height of the eyebrow and ending at the level of the nose. Mirror this on the right-hand side.

Add a V shape in the middle of the forehead on the top line of our original square. Colour in the hair area.

Now we can add some shading between the nostrils and the top lip to suggest a moustache. Shade in the chin outline loosely to suggest beard growth. Add a bit of light shading on the left-hand side of the face and under the eyebrows.

Now add the neck by drawing two vertical lines down from the left and right sides of the square. Add shading under the chin. For the shoulders add two sloping lines at around the chin level. Darken the chin line a little to suggest a slight beard.

And there you have it. David Beckham! Not bad for your first effort, huh?

HANDY HINT

As a general rule, the lightest part of somebody's face is the forehead and the darkest part is under the chin.

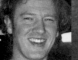
Exercise Two: How to Draw Picasso's Dove

Below is an image I created after Picasso's drawing of a dove. Can you see what shape we'll be using for this exercise? Are you starting to see like an artist yet?

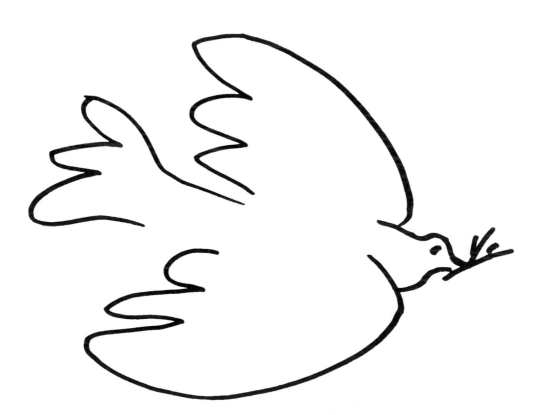

Hey presto! The dove has a circle-shaped form.

You will need a pencil, paper and black marker pen to draw the dove.

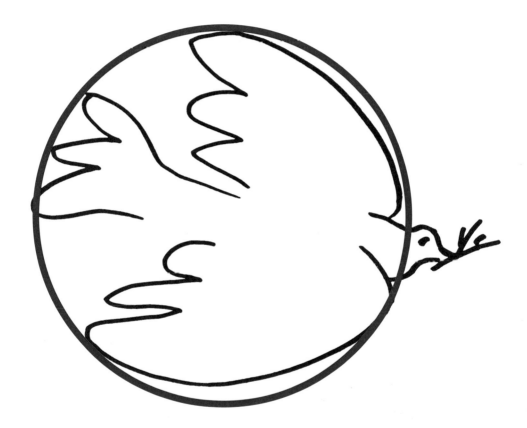

ARTY FACT

Doves have a history of symbolism in art and have been used by artists to represent things such as peace, fidelity and spirit.

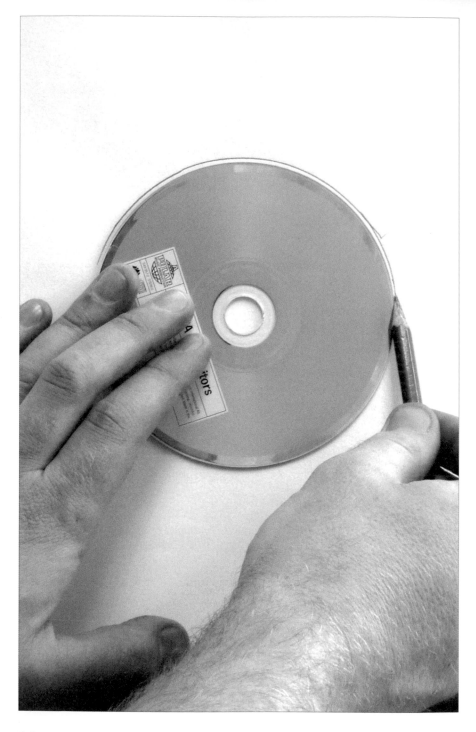

Step one

Get yourself something circular – I used a CD for this exercise – and place it in the middle of the paper so that you leave enough space around it for the rest of the picture later. You should be left with a roughly drawn circle on your page like this.

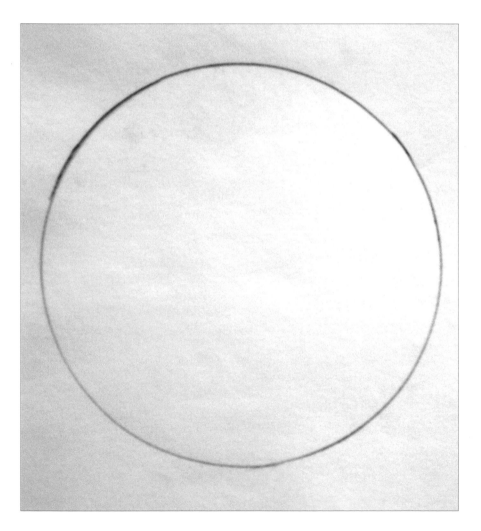

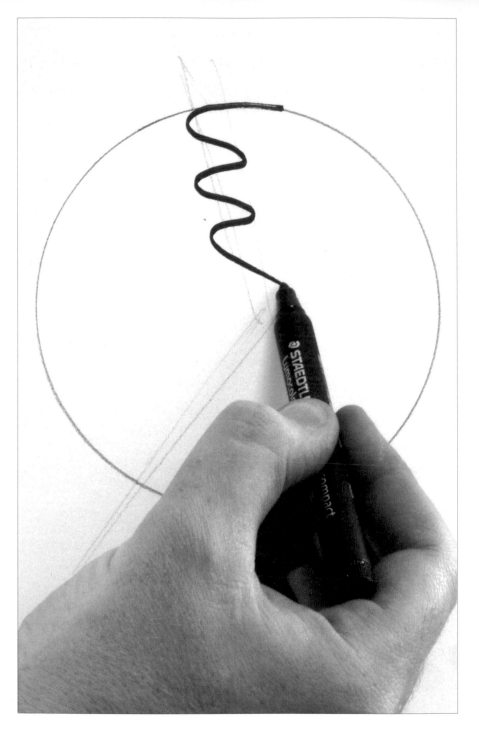

Make a rough V shape with your pencil. The tip of the V should be pointing to the right and be roughly in the centre of the circle. We are going to use this V shape as a guide for thc wings.

The secret to what we are going to do next is quick, fluid strokes. Think of it as doodling. Pick up your marker and, starting from the top of the circle, draw a three-pronged squiggle much like the one you see opposite. The squiggle should finish just short of the centre of the circle.

Now let's draw the next wing. Just below the centre of the circle, using the pencil line you made as a guide, draw another three-pronged squiggle.

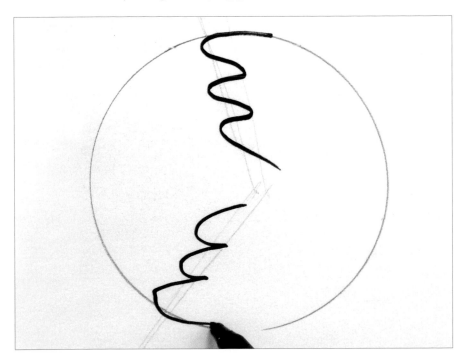

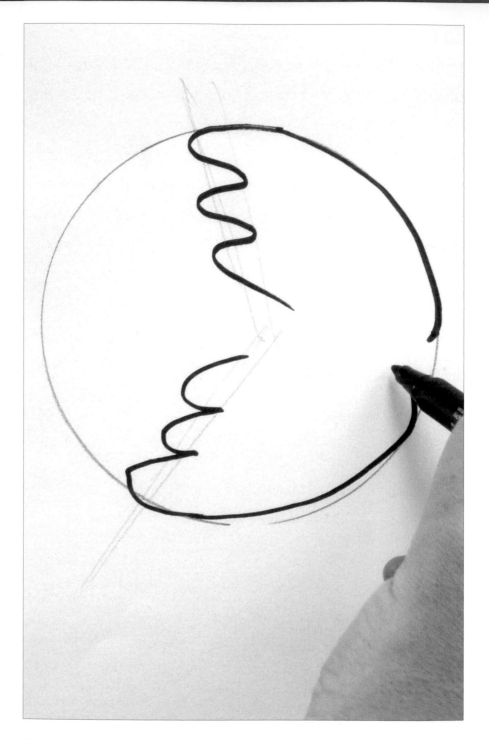

Step two

Now continue the line of the top squiggle along the edge of the circle. Stop the line roughly halfway down the circle. The whole wing should be about a quarter of the circle in size.

Do the same at the bottom for the lower wing, but this time curl back towards the centre halfway up to suggest the shoulder of the wing.

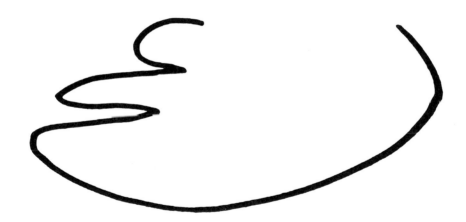

HANDY HINT

Remember: lighter pressure, thinner line. If you don't press as hard on the paper with your pen or pencil, the line becomes thinner. A light line can add subtlety to a drawing, or it can make something look further away.

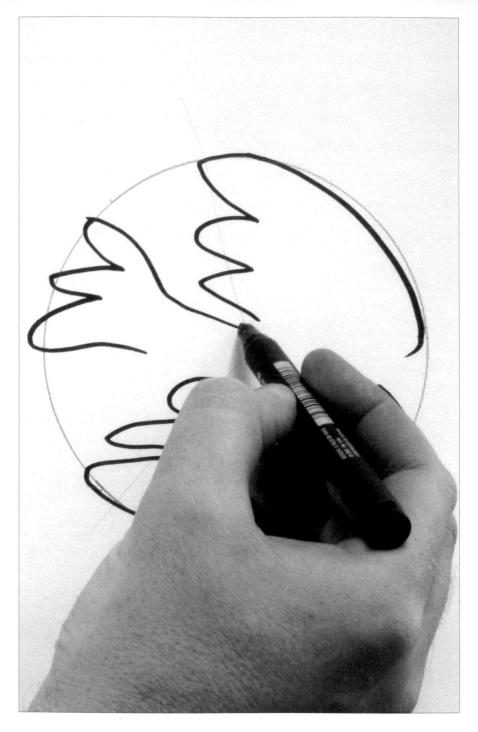

Step three

Now we're going to draw the tail. On the left-hand side of the circle, halfway up, draw a three-pronged squiggle like the one on the left. The tips of the feathers should be within the circle's edge. Now, using slightly lighter pressure on the paper so the line is thinner, bring the top of the squiggle over into the centre of the circle, finishing just above the centre of the circle. This represents the bottom of the spine of the bird.

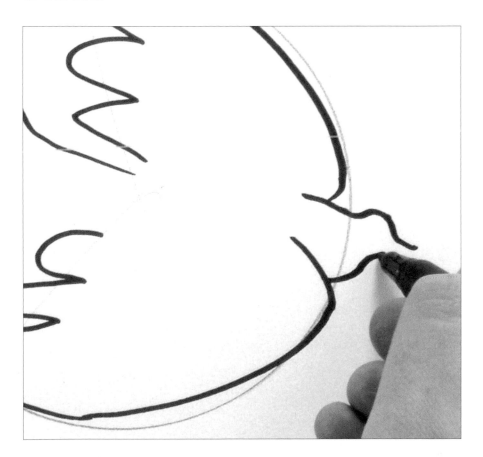

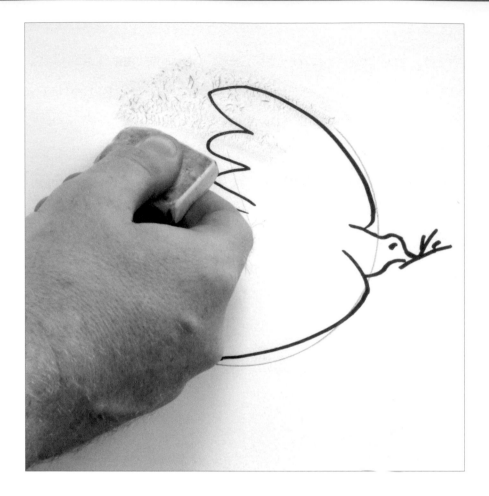

Now let's draw the head. Move over to the right of the circle below the shoulder of the top wing and, at about the same level as where the spine line finishes, begin drawing the neck of the bird and the top of its head. Draw the line with a slight bump in it to suggest the skull. Now, behind the shoulder of the lower wing, draw a flattened S shape towards the beak, tailing off to suggest the bottom of the beak.

Step four

Finally, the finishing touches. For the eye, add a small dot in the upper middle of the dove's head. For a sprig, draw a short diagonal line just touching the tip of the beak and add a few short strokes to suggest twigs.

As we drew the dove using black marker pen and only used the pencil lines as guides, we can erase them to finish off our drawing. Take a rubber and erase all the pencil marks. Now admire your masterpiece. Picasso would be proud of you!

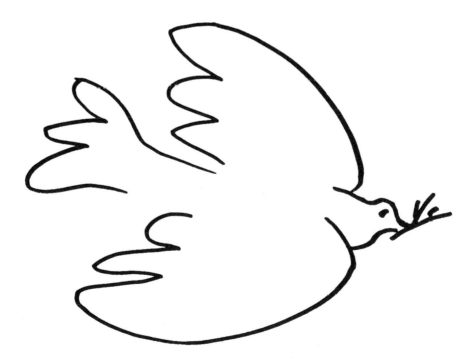

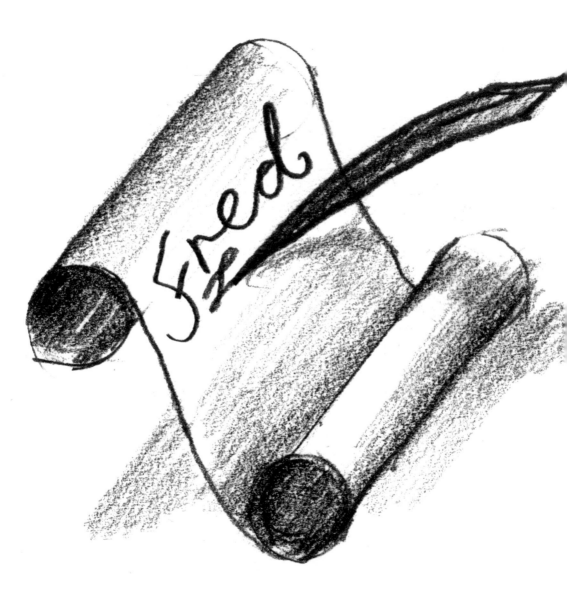

Exercise Three: How to Draw a Scroll

Opposite is an image of a scroll and a quill. Can you see what shapes we will be using to create this image? I think you are beginning to see like an artist …

Correct! The scroll has circles and oblong shapes in it. You will need a pencil, paper and eraser to draw the scroll and quill. To draw around you will need an AA-size battery.

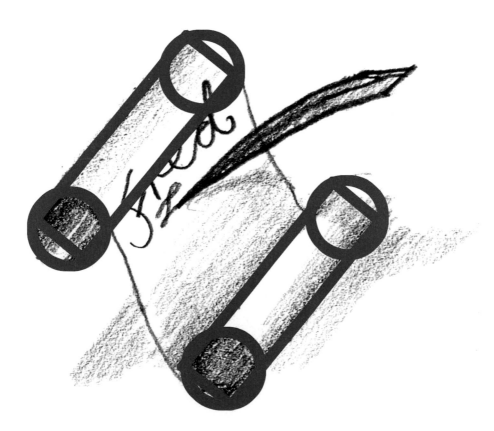

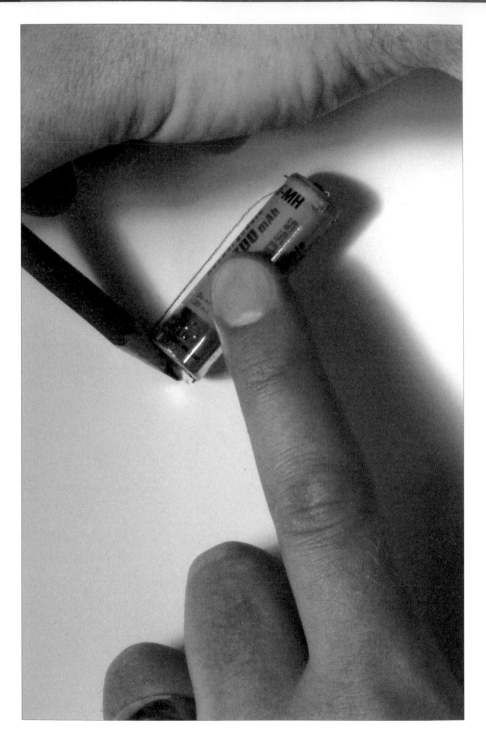

Step one

Take the AA battery and place it diagonally on the paper, leaving enough space around it to finish the drawing later. Draw around the battery with your pencil.

Now turn the battery on its end and, at both the bottom and the top of the oblong shape you have created, draw around the base of the battery so you have a circle shape at each end.

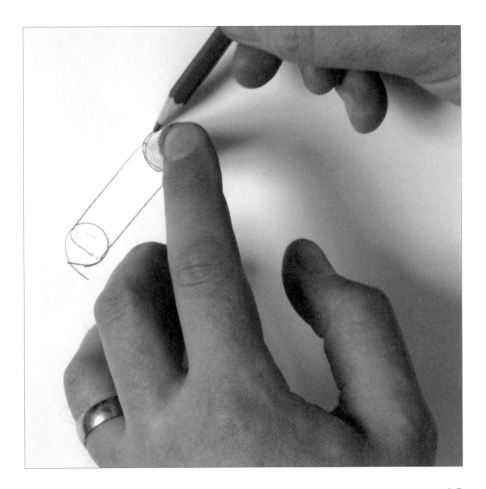

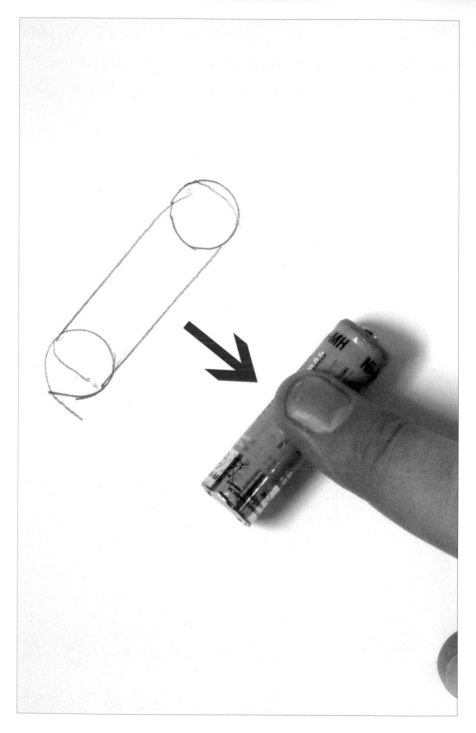

Place the battery in its original position, then roll it along the paper on its axis until is about its own length down the paper (see the picture opposite). Now repeat the process so that it looks something like this:

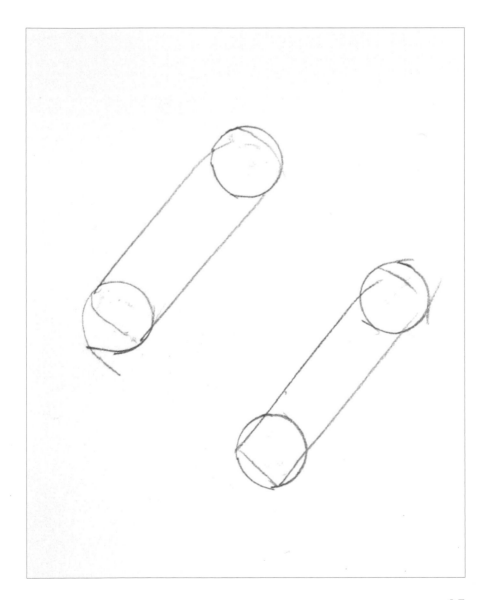

Step two

To give the impression of paper rolling between the two rolls, we need to connect the rolls together. From the top of the leftmost circle, make a back-to-front S shape to the bottom of the lower circle. Repeat this at the top of the scroll. Try and keep the lines parallel and draw them with a nice broad sweep of your pencil.

Now we can draw the quill. Somewhere in the top half of the parchment draw an elongated < shape. Close this with a short > at its end. You should have what looks like

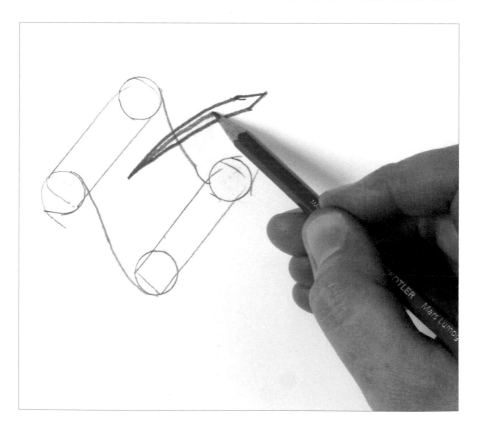

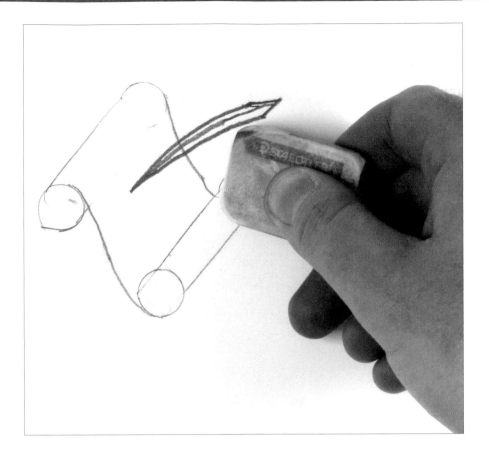

a feather. Try and give it a slight curve as no feathers are exactly straight, then draw in the spine of the feather with a line going down its middle.

I hope you have noticed how important the eraser is by now. It is as important to take marks off the paper as it is to put them on. Our next job is to rub out our structure lines. At the moment it looks like a transparent plastic scroll; to make the paper 'opaque' we need to erase all the lines that don't need to appear.

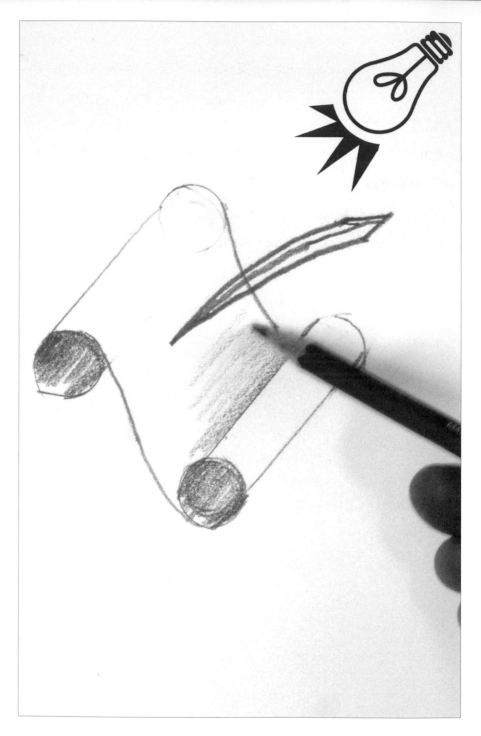

Step three

At the moment, your drawing is just the outline of a scroll. Now we are going to employ some shading to give it the look of being a solid object. We'll assume the light source is coming from above – where the bulb appears in the picture opposite.

First of all shade in the circles. Make the upper parts of the circles directly underneath the scroll paper slightly darker. Add some light pencil shading to the scroll itself on the lower portion below the quill. Use the pencil very

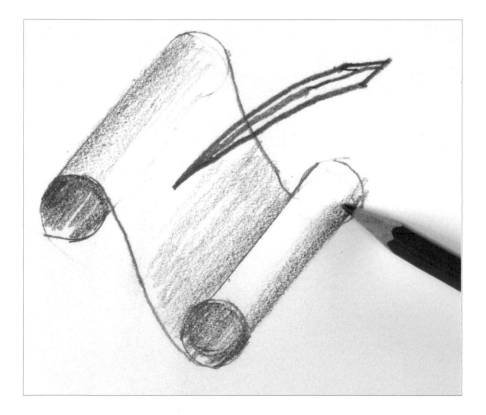

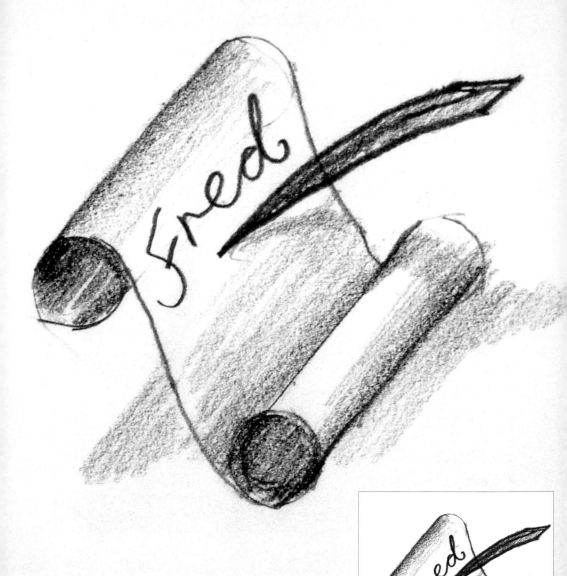

lightly to fade it out a bit towards the middle. Now add some shading at the top and bottom of the scroll.

Step four

Shade in the quill to make the tip slightly darker than the tail feathers using pressure with the pencil.

Shade in the shadow on the ground lightly. Add the shadow for the feather – a little bit in the middle of the scroll and on the lower roll. The shadow on the roll should be slightly round so it appears to bend around the roll and follow its form.

Finally, add your name if you want to – after all, you did it!

HANDY HINT

If you want to 'weight' an object in a scene – to make it look part of the scene – give it a shadow. If you don't, your object or person will look 'floaty' and not 'grounded'. Think about where the source of light is in this drawing, then add a shading on the ground where the object would logically cast a shadow.

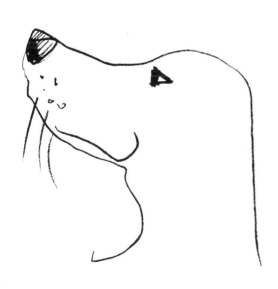

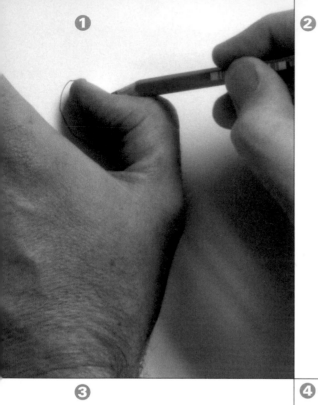

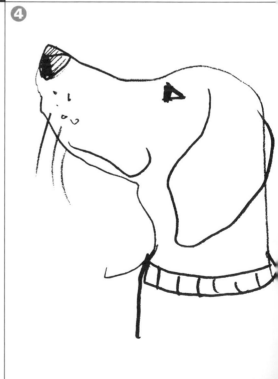

Exercise Four: How to Draw a Dog's Head

The final exercise in this section does not use any of the shapes we have been looking at, but it does use a shape you are very familiar with. Believe it or not, a dog's head can be drawn by drawing round your thumb!

Step one
Draw around your bent thumb.

Step two
Add the nose.

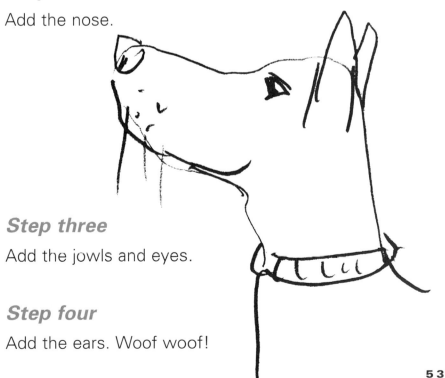

Step three
Add the jowls and eyes.

Step four
Add the ears. Woof woof!

5 3

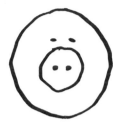
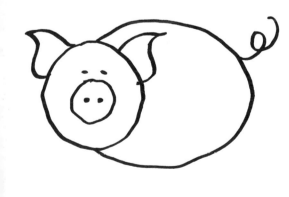
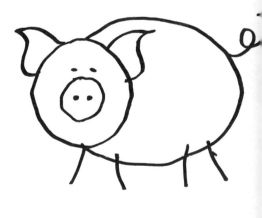

2

Thinking like an artist

'We must ... give the image of what we actually see,
forgetting everything that has been seen before.'
PAUL CEZANNE

THINKING LIKE AN ARTIST

At this juncture in the book, I would like you to have a little rest.

You have been introduced to a way of drawing using shapes to guide you, and you've done incredibly well. For our next lesson, I am going to help you to start *thinking* like an artist so you will be able to move to the next stage of our journey smoothly.

To *draw* like an artist you have to *think* like an artist. To *think* like an artist you have to *see* like an artist. Drawing what you see, in the exercises to come, will mean capturing what you see *from observation*, from *looking* closely at something in front of you. To really see – to see like an artist – you have to forget what you know already and start from scratch.

By this, I don't mean forgetting what we have just learned regarding shapes; rather, I want you to forget about the symbols we use for things in our head. We need to look again at something in front of us as if we have just opened our eyes for the very first time.

BRAIN STUFF

If I asked you to draw a pair of lips, you wouldn't answer, 'I can't, because I can't see any lips.' You would use your memory and draw what you know or think lips look like, and it would probably look something like this:

Now, here's where it all gets a bit scientific. When you do this, you are using the left-hand side of your brain. This is the part of the brain that deals with symbols, words and logic. You know what this drawing is of because it's a universally recognised symbol for lips. When you doodle and draw a house or a flower, it is the left-hand side of your brain that you are using.

To draw like an artist, you need to learn how to utilise the right-hand side of your brain. If we were to draw somebody's lips like an artist, from observation, they might look something like this:

We are not drawing the lips 'literally'; we are suggesting them through the shadow that their form makes, and we are leaving out things that are not necessary. It's the same as when we break things down into shapes – we are looking at the big picture, not the details.

By Collette Furr, aged seven

I've already quoted Picasso once, but I'm going to quote him again: 'Every child is an artist. The problem is how to remain an artist once he grows up.' I have a good reason for doing so. Think of a drawing or painting you did as a child, or look at a young child's work (such as that on the right). Usually, they are pictures of the family or a house in a field. They are intuitively well-composed pictures. They don't draw things all at the bottom edge of the picture or tiny figures surrounded by the space of the paper. The paper is completely filled and the balance of forms that appear in the picture is very good. This natural early ability to compose is because 'in the early stages, infants' brain hemispheres are not clearly specialized for separate functions' (*Drawing on the Right Side of the Brain* by Betty Edwards).

TWO WAYS TO DRAW A PIG

Pig one

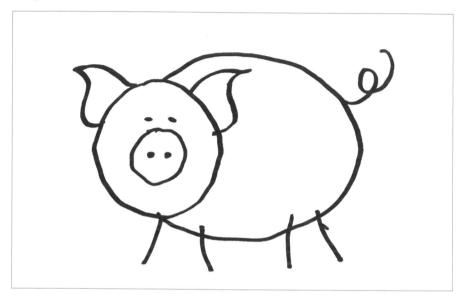

Pig two

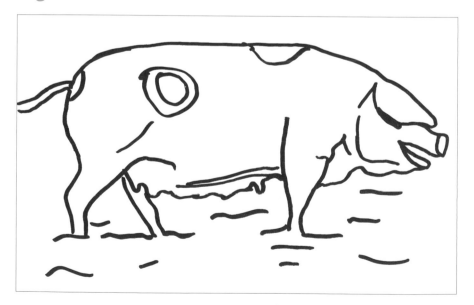

Opposite are two different drawings of pigs. They are both recognisable as pigs, but we are going to draw them in different ways.

Pig number one has been drawn from memory. I have used the circle shapes as symbols for the snout and for the head. This is the kind of pig you would draw in a game of visual communication. You use shortcuts to convey your message. You use the store of visual symbols from the left-hand side of the brain to help you. Before you start drawing you think to yourself, A pig has a round snout with two holes in it for nostrils. A pig has small eyes like dots and flappy ears. A pig has a curly tail. A pig has four legs. This is the way people draw before they rediscover the lost art.

Pig number two has been drawn from observation. It has only three legs because that is all I saw when the animal was in front of me. The other front leg was obscured. I couldn't see it so I didn't put it in. It didn't matter. I couldn't see any eyes so I didn't put any in. I drew what I saw.

For fun, you are now going to draw pig one; after you've done that, you are going to draw pig two.

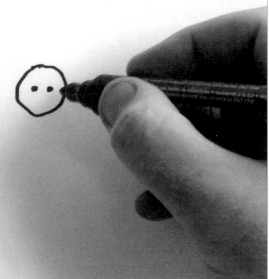

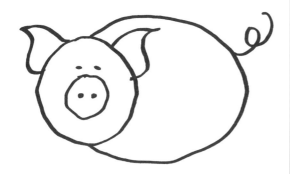

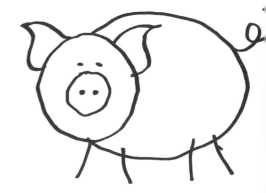

Exercise Five: How to Draw Pig Number One

Step one

OK, let's think about what a pig looks like. Well, it has a round snout, so let's draw a circle. Draw two dots in the centre for the nostrils.

Step two

Draw the eyes above the snout. Now draw a bigger circle around all of what we've done for the head.

Step three

At either side of the head at the top, add two flappy ears ending at eye level. Draw a big egg shape to the right for the body.

Step four

Finally, add four sticks for legs, and a curly tail.

And there you have it. A pig. Fun, huh? Now, I want you to forget what you have just done in this exercise. I am going to turn your world upside down.

'Two roads diverged in a wood and I,
I took the one less travelled by.'
ROBERT FROST

'As an artist you have to assassinate yourself
in order to progress.'
PABLO PICASSO

'Insanity: doing the same thing over and over again
and expecting different results.'
ALBERT EINSTEIN

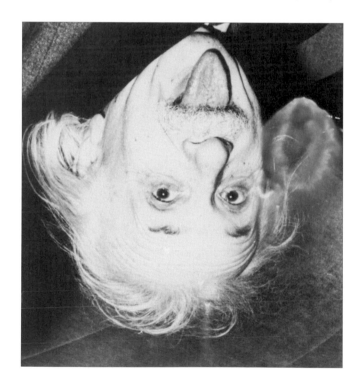

You have to be open-minded and try different ways of getting to the place you want to be …

Exercise Six: How to Draw Pig Number Two

What you see below is not a pig; it is an arrangement of lines. Don't try and recognise what is what in this image. It doesn't matter.

Drawing something upside down makes us look at it in terms of shapes, lines and balance. It makes us look at it in an objective way. We don't worry about making it look *like* anything. We are looking at getting the balance of shapes right, and the lines in the right place. We are going to draw this image as it is, and not turn it the right side up until we have finished our drawing.

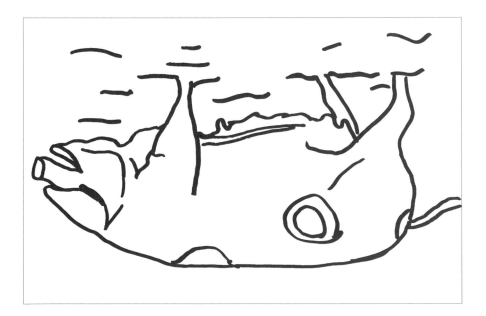

Get a sheet of A4 paper and look at the rectangle of the drawing overleaf as the edge of your sheet of paper. Take your pencil or pen and start anywhere you like. Take your time. Don't draw the whole outline first, but work on an area at a time, trying to make all the parts fit together like a jigsaw. If you talk to yourself while you are drawing, don't *name* anything – say things like 'this line is this much away from the edge of the paper' or 'this bit is in line with this bit' or 'this curve goes around here'.

All the information you need is right there in front of you – all you have to do is draw it, to work out where something should be on your paper. Take as long as you like, and draw over lines you don't think are right if you need to.

When you are done, turn your image the right way round.

Exercise Seven: Drawing a Goblet/Symmetry

Below is an almost abstract image of a white goblet on a black background. I want you to copy it.

Draw yourself a square on your paper. If you are using a sheet of A4, you may want to fold it in half lengthways then flatten it out again to give you a folded crease down the middle of the paper. The folded crease can be your guide going vertically down the middle of the square.

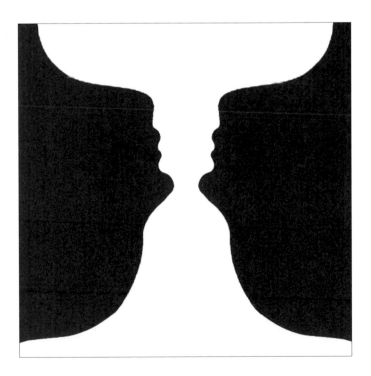

Before you start, have a look at the drawing you are going to copy. Take in the balance of the picture. See where the main black areas are and how narrow the white bit is in the middle. When you are ready, start to draw the left-hand side.

Start slowly from the top and constantly check the line you are drawing to see that it is going in the direction you want it to. If you think you are going too far out, stop and start a new line where you think it should be. This is part of the drawing process, and is allowed! Artists call these 'lost and found' lines. As you draw, keep thinking: Where does this curve start? How shallow is this curve? How far away is this curve from the edge of the square? If the middle of the paper is here, how close do I go to the middle of the paper with this curve? How far is this curve down the square?

Once you have drawn the left-hand side of the goblet, do the right-hand side. This image is about symmetry and balance. The right-hand side is exactly the same as the left-hand side only it is mirrored. Fold the paper back over and trace over the line on the left that you have already done. When you open the paper up again, you have a guide line from the other side of the paper that you can draw over for the right-hand side.

When you have finished, turn your picture upside down. It is two faces looking at each other. Now, you may have known this, as it's quite a popular optical illusion. But hopefully, because you weren't concentrating on naming specific areas of the face and using the 'verbal' side of your brain, you found it easier to replicate the forms.

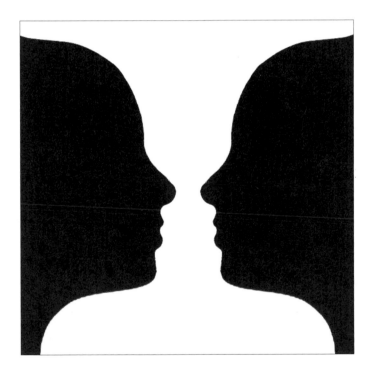

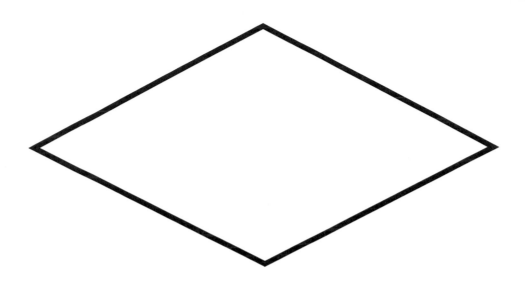

Exercise Eight: How to Draw a Three-dimensional Cube

'Painting,' said Picasso, 'is a lie that tells the truth.' If I told you the diamond shape above was the top of a cube, would you believe me? Get your pencil and paper ready. We all know that a cube is made up of squares. But we should be aware that the shapes we are familiar with in the real world appear differently on paper or canvas. We are going to be dealing with the effects of perspective and foreshortening later in the book, but for now we are going to do an introductory exercise that will make you understand how the diamond above will seemingly

transform itself from a two-dimensional shape into a three-dimensional one.

Step one

Have a look at the images overleaf. To help you draw the diamond, we are going to create guide lines again. The guide lines we are going to create will be parallel to the edges of the paper. Draw a vertical line down the middle of your paper, then draw a horizontal line across it, in the middle, so you have a cross in the middle of your paper.

Now draw the diamond shape with its points converging on the 'crosshair' lines. The top half of the diamond shape should be the same in width as the bottom half.

Step two

Measure one side of the diamond with your pencil. The next line you are going to draw – the bottom left-hand line of the cube – should be that distance below the bottom left-hand line of the diamond (see the illustration overleaf). Lay your pencil on the lower left-hand side of the diamond shape. Now move your pencil down vertically on the paper at exactly the same angle. Draw a line at this angle using your pencil as a guide. It should

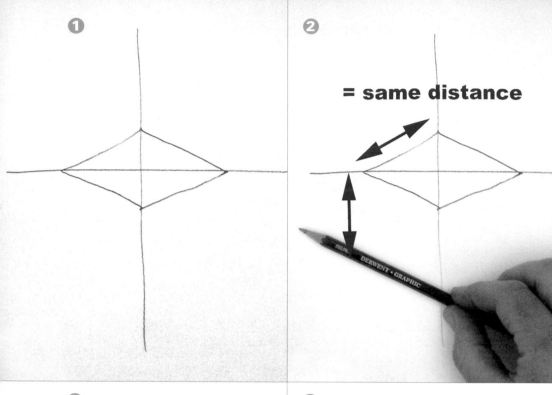

❶

❷

= same distance

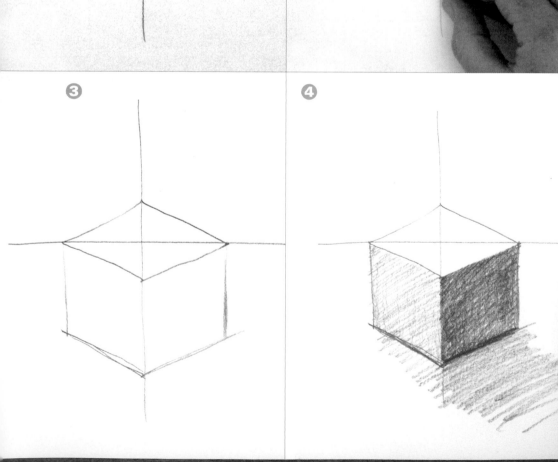

❸

❹

start below the left-hand corner of the diamond, and end at the vertical crosshair line.

Step three

Draw the other lower side of the cube in the same way, then draw the sides. The sides should be parallel to the vertical line you drew originally.

Step four

Now add some shading. Make one side darker than the other by drawing the shading more heavily. Define the lines where the cube sits on the ground by reinforcing them with your pencil. Finally, add a shadow coming off to the right, as the light source would be coming from the top left of our picture.

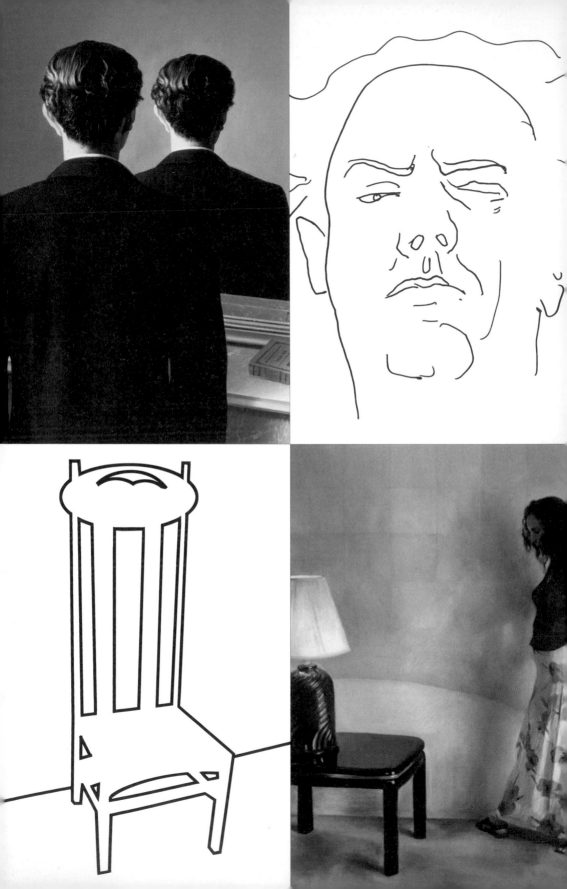

3

Seven ways of
helping you draw

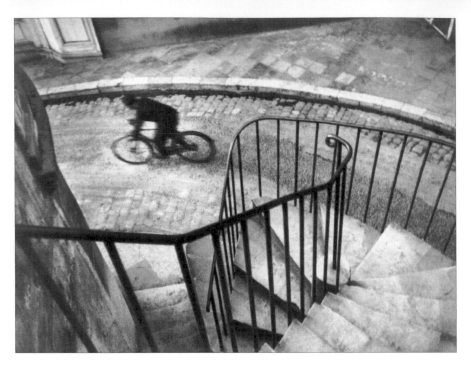

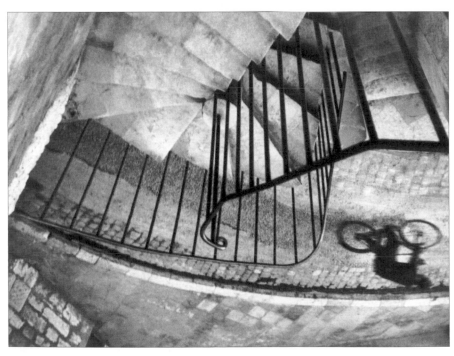

SEVEN WAYS OF HELPING YOU DRAW

NUMBER ONE: UPSIDE DOWN/SIDEWAYS

To check if the composition of his photographs was right, the photographer and artist Henri Cartier-Bresson used to turn the photo upside down. The photo opposite is a great example. Cover the top photo with some paper and have a look at it the wrong way round. The cyclist becomes less important, but the image still works as an abstract composition – the cyclist becomes another element of the composition in the right place at the right time. Now when you look at the image the right way up, you appreciate it even more.

As we learned in exercise six, drawing something upside down when we are copying it makes us look at it in terms of shapes, lines and balance on the paper or canvas. It makes us look at it in an objective way – as we are not 'recognising' anything, we don't worry about making it look *like* anything. We are just looking at getting the balance and proportion of shapes right.

This method also works if you flip something sideways, both left and right.

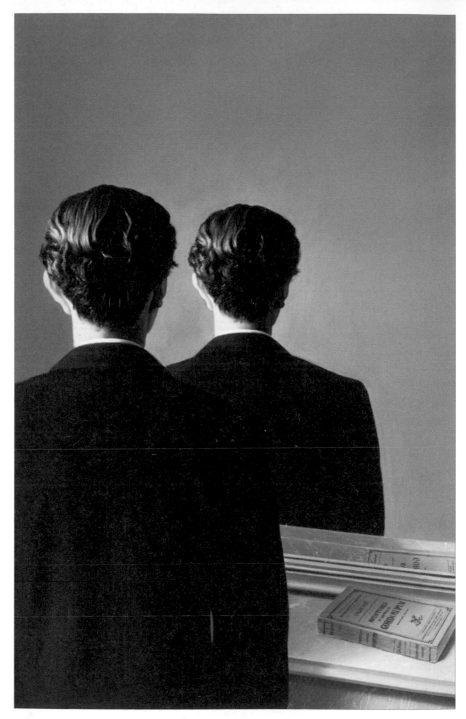

NUMBER TWO: LOOK IN A MIRROR

Whether it is a landscape, a still life or a person you are drawing or painting, looking at it in a mirror is an invaluable way of helping you look at your work objectively and so get the balance right. It works on the same principle as looking at something upside down, only it makes your image back to front. If you are drawing somebody's face and one of their eyes is lower or smaller than the other, for example, you will immediately see this in a mirror when you might not notice it otherwise.

ARTY FACT

Mirrors have long been used as subject matter in paintings as devices for allowing the artist to play tricks and make the viewer question the semblance of reality in the painting itself.

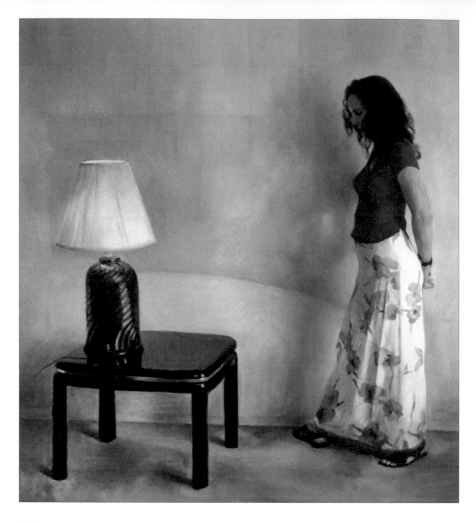

NUMBER THREE: NEGATIVE SPACE

When a composer composes a piece of music, the quiet bits are just as important as the noisy bits. It's just the same with an artistic composition: the bits that are *not* there are just as important as the bits that *are*.

Negative space is the space that surrounds an object or a person. We talked earlier about everything being made

up of shapes, and the space that surrounds things has a shape too. When we look at negative spaces surrounding something, we can look at them as abstract shapes; if we get these shapes right in relation to each other, the positive shapes will also fall into place. It's a bit like finding the right piece for a jigsaw.

Have a look at the painting opposite. The shape between the girl's arm and her body is a negative space and has a shape in its own right, as has the shape between the lamp, table and dress.

 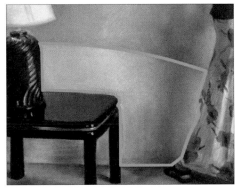

Look for the negative spaces around you. Looking at the spaces between things and the edge of your picture will help you get the proportions of the picture right and compose the picture properly. If you look at the painting opposite, the spaces around the girl and the objects are fairly even. Can you spot any more negative spaces in this picture?

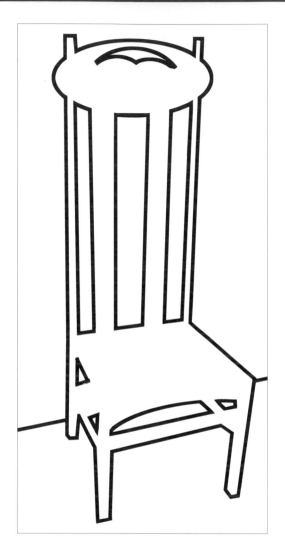

Exercise Nine: Drawing Negative Space

If you draw a chair, you need to look at the spaces of the chair as much as the chair itself. The drawing above is based on a chair made by the Scottish art nouveau artist/architect/designer Charles Rennie Mackintosh. It has a distinctive shape and style. I want you to colour this

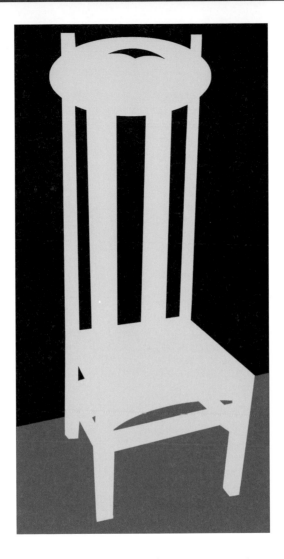

image in – you can do it in the book, or make a photocopy
if you prefer. Use coloured pencils to fill in the spaces
around the chair instead of the chair itself. Only when you
have filled in the background and the ground should
you fill in the chair.

NUMBER FOUR: COMPOSITION

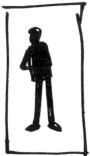

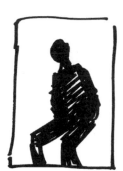

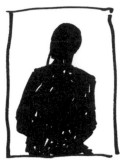

| Unusual | Full Length | Three Quarter | Head & Hands |

| Head & Shoulders | Head Study | Close-Up |

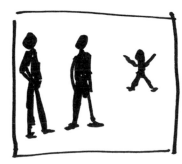

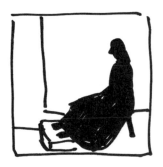

| Cropped Off | Group Portrait | Self Portrait |

We have learned about the importance of negative space in a picture. Now we need to know that what we choose to select or leave out in our picture affects how the final picture will look.

Opposite, you will see what are known as 'thumbnail sketches' of different compositions. I have used the human figure as the subject matter. These pictures serve to show just how many possibilities there are when you come to compose your picture. If there's something you want to focus on, you compose the picture accordingly. The size and proportions of your paper edges or canvas (the 'format') will reflect how you want to compose your picture too. So, for instance, a full-length portrait of somebody could be long and thin, while a head study might have a rectangular format.

HANDY HINT

A great way of establishing a composition you like is to do a quick thumbnail sketch of it. A thumbnail sketch is a very small, quick sketch, no bigger than a few centimetres across, in which you can quickly sketch the format of the picture you want. This way, before you set out on a big picture that is possibly going to take a long time, you can work out exactly what you want it to do in tiny format. Often, if the composition works in a tiny format, it will work on a large scale too.

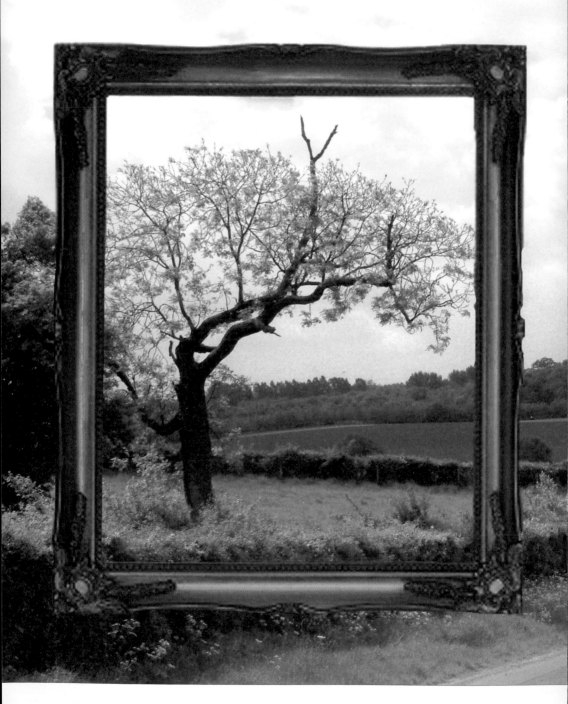

NUMBER FIVE: THE PICTURE PLANE

Imagine you are in the country. You hold an empty picture frame to the scene in front of you. You frame the scene how you think it looks best. Now, imagine that what you have framed becomes a picture on canvas in the frame. The three-dimensional image has become a flat two-dimensional object. This is the picture plane: the edges of the picture are the edges of the plane.

During the Renaissance, the artist Leon Battista Alberti was looking through a window at the buildings in the distance when he realised he could replicate perspective by tracing over the image he saw before him directly on to the glass. Just as we discovered in exercise eight when we drew a cube, the lines of a cube (or a building) that are parallel to one another in real life are not necessarily parallel to the plane of the window, or the picture plane.

ARTY FACT

The artist Cezanne was a master of manipulating elements within the picture plane to distort perspective. He would deliberately make things that were further away look closer than they were, and things that were closer look further away – so everything seemed to be 'flattened' on to the picture plane. (see picture of Cezanne's Montagne St Victoire on page 204)

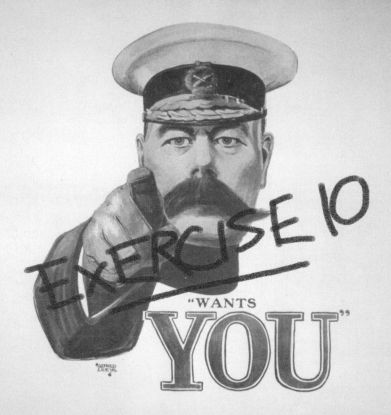

Exercise Ten: Using a Picture Plane to Draw

In the picture of Lord Kitchener opposite, you will see that his finger is pointing directly out of the picture. This is what is known as 'foreshortening'.

The picture below by Albrecht Dürer depicts the artist looking at an unusual foreshortened view of a model through a picture-plane device that is helping him to capture this difficult viewpoint. When using a device like

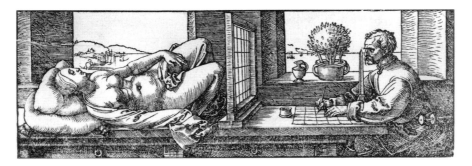

this one, it is important to keep your head still. It is one of the greatest challenges of the artist to capture fore-shortening, and I think Dürer has managed to represent the absolute concentration and immobility of the artist's head in this picture.

We are going to use a CD cover as a simple picture-plane device to draw a foreshortened self-portrait. You will need a clear plastic CD cover, a mirror slightly bigger than the size of the CD cover and a non-permanent black marker.

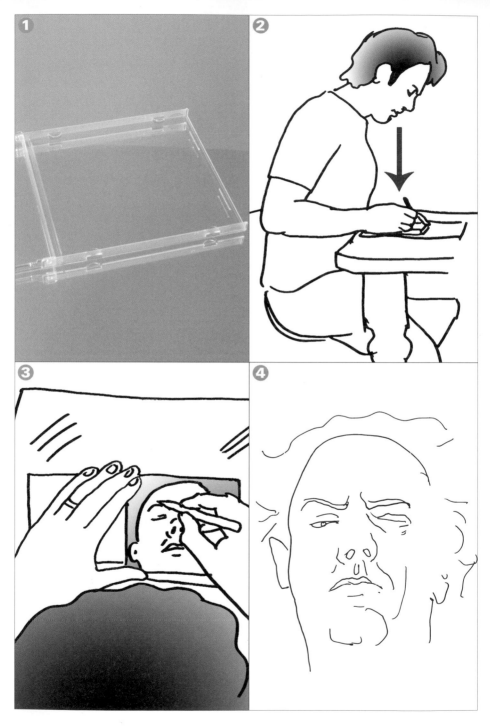

Step one

Sit at a table in a comfy chair and place the mirror flat on the table. Take out all the sleeve notes from the CD so you are left with a clear plastic cover. Place the flat side of the front cover directly on the mirror in front of you.

Step two

Place your head directly over the CD cover so it is framed tightly by its edges. The CD cover is now your picture plane. The view you have of yourself won't be the most flattering as it is foreshortened and you are looking down at yourself. You will need to keep your head perfectly still and one eye closed so you are getting one view only.

Step three

Take your marker pen and begin to trace around the contours of your face. Draw around your closed eye, your eyebrows, your open eye and your other features. You must keep your head still throughout.

Step four

Once you have finished you should have something on the CD cover that resembles a foreshortened view of your face. In the past, the artist would have traced this on to

their paper or canvas and used it as a basis for their painting. If you hold the CD cover up to a desk lamp, you will see it projects a larger image on to a wall. You could trace around the image this way too.

NUMBER SIX: GRIDDING UP

There are a number of reasons for gridding up your paper or canvas. You can draw a grid to transfer a smaller

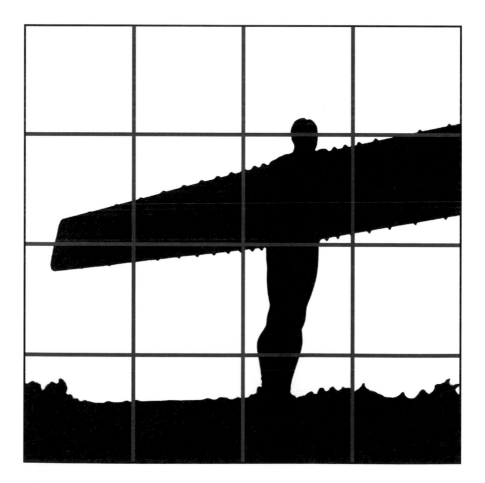

sketch on to a bigger format and keep the same proportions, or you can use it as a means to help you get the angles and proportions of things right. Any horizontal or vertical guide lines you draw on your picture should always be parallel to the edges of your picture.

Picture-plane devices in the past very often had a grid system of wires in them. Take a look again at the Dürer picture on page 89. The grid of the device has been transferred to the artist's paper. If you look at the painting *Girl with Light* on page 80 you will, if you look hard enough at the wall behind the lamp, see the little squares of a grid.

Exercise Eleven: Using a Grid to Draw

Opposite is a black and white illustration of Anthony Gormley's sculpture called *Angel of the North*.

I would like you to draw a square and divide it up into sixteen smaller squares. I then want you to replicate this image using pencil, charcoal or paint. Work on one square at a time, treating each square as a picture in its own right. Pay attention to how much white (negative space) appears in the square you are working on. Also pay attention to the angle of the wing in relation to the horizontal lines going across the picture. You can turn the picture upside down or sideways to help you look at it in an abstract way.

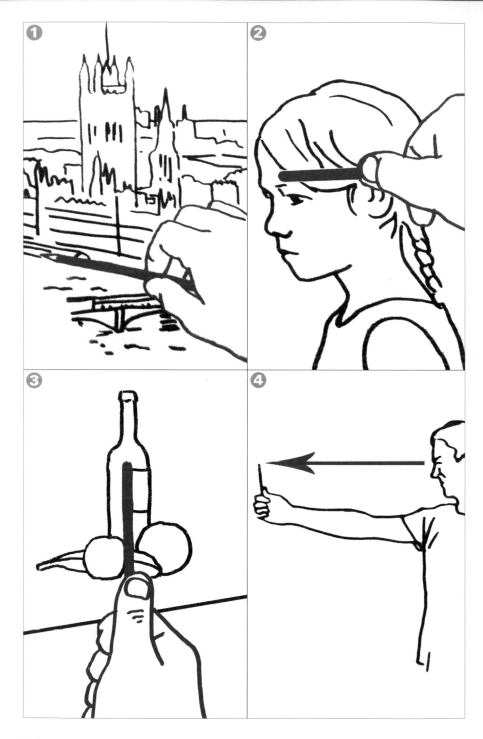

NUMBER SEVEN: MEASURING

You measure things when you are drawing or painting by holding up your pencil or brush at arm's length and holding it as though it is flat on the invisible picture plane in front of you. You can measure for one of three reasons:

Fig 1: To work out an angle of something such as a building's edge.

Fig 2: To get a basic unit of measurement. If you roughly measure a part of the scene in front of you, you can use this as a unit of measurement to measure other things against.

Fig 3: To get a horizontal or vertical sight line to see what in the scene is in line with something else.

Fig 4: The correct way to measure with your brush or pencil is to close one eye, hold your arm as straight as possible, locking your elbow, and place the pencil or brush in your line of sight.

Once we have taken an angle or measurement we can keep the pencil as it is and transfer it to our paper or canvas.

ARTY FACT

The artist Euan Uglow, who was a teacher at the Slade School of Art in London, inspired a whole school of painting based on measuring things. All the strict measurements he made while painting his subjects were left in the final work.

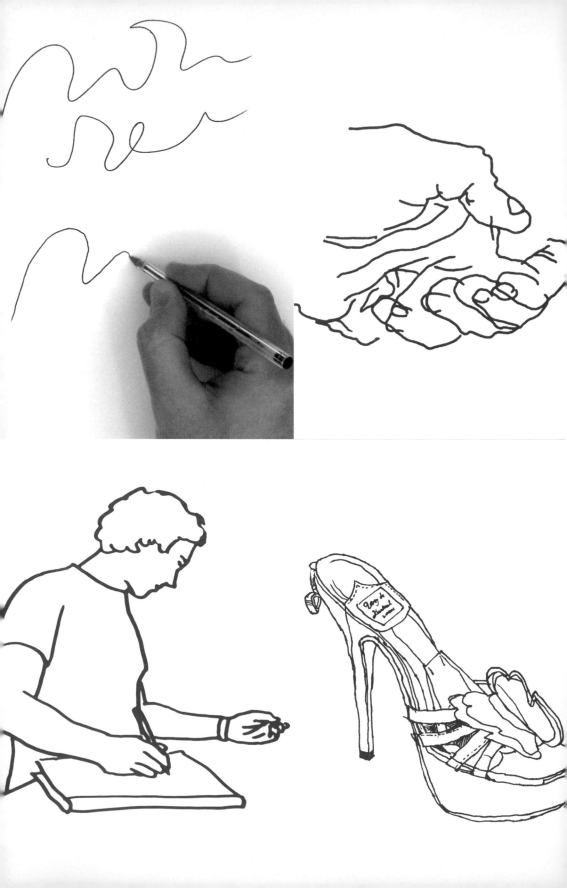

4

Introducing line drawing

INTRODUCING LINE DRAWING

Exercise Twelve: Drawing a Squiggle

This may sound a bit silly, but this is an exercise in *looking*. Don't worry that you won't have anything recognisable at the end of it – it's just an exercise – but it will help you to look at what you are drawing in a different way.

The first thing I want you to do is pick up anything you have to hand and draw a squiggle. Draw another one if you like, and another. That was easy, wasn't it?

Now stop. Right below your squiggles I want you to copy them. That's right – copy what you have just done. Have a look at your squiggle objectively first. Then, when you're ready to begin, put your pencil on the paper at the point that corresponds with the beginning of your squiggle and *very slowly* start to record what you see, taking in all the bends, swirls and bumps. Keep your pencil on the paper, so you have one continuous line echoing every twist and turn. Look back and forth between the line you are drawing and the squiggle you are copying.

This has got to be done in one continuous line – no

99

stopping and drawing another line, which is why you have to do it very slowly. Think about those things you get at funfairs, wires with a loop around them. You have to go around the wire with the loop not touching it. Pay the same attention to the line you are copying.

When you have finished, review what you have done. How close is the copy to the original squiggle? It's a strange idea, drawing something spontaneously and without thinking, then replicating it through looking at it.

Through doing this exercise you have experienced the beauty of pure line. A pure line is one that is continuous and unbroken.

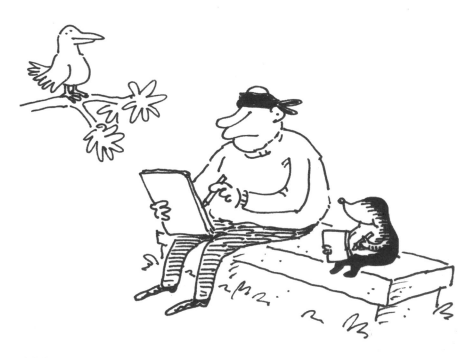

Exercise Thirteen: Blind Drawing

If I said to you I want you to draw something without looking at your paper once, would you think I was mad? Well, that is what 'blind drawing' is all about.

This is probably the hardest exercise in the book. But I believe that, if you put yourself through the pain barrier, you will come out the other side the better for it. I am going to ask you to draw your own hand without once

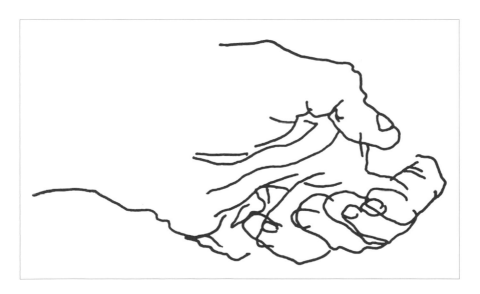

looking at your paper. Again, this is an exercise, so there does not need to be a recognisable result at the end of it. It is just another way to draw and another way of helping you look at things like an artist – and you might even enjoy it!

Look at the palm of your hand – the hand you don't draw with. Scrunch it up so you have a lot of wrinkles in it, and make sure the paper you are going to draw on doesn't move about. Put the hand you are not drawing with up on the table in front of you as far from your drawing paper as possible.

Take your pencil and start drawing what you see. Start with a wrinkle. Go very slowly. Follow the line of the wrinkle. Let your pencil follow the movement of your eye along the line. If the wrinkle stops, go on to the next one. Don't look where you should be drawing it, just believe in your intuition. Feel the force. If you hear voices from yourself saying 'This is stupid!', ignore them and carry on. After five minutes turn and look at your drawing.

Chances are it will look like nothing but a mass of lines – and that is what it is *meant* to look like. This was an exercise in achieving a meditative state of observation. For the time you were doing it, you understood as an artist and lost yourself in complete attention to what you

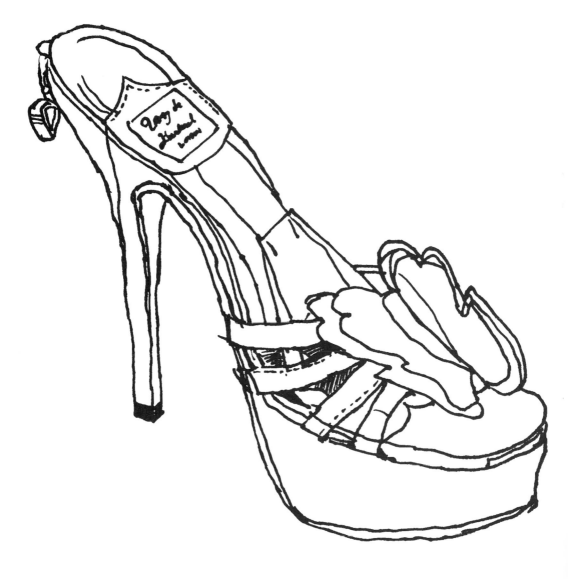

were looking at. You have been making marks based on observation and nothing else. You were 'at one' with the thing you were concentrating on.

Exercise Fourteen: Line Drawing of an Object

This exercise is going to put your line drawing into practice. Line drawing, as we have just found out, is a way of drawing that encourages us to observe the edges of what we are looking at. It is almost the opposite of measuring as it helps to free us up a bit. The end results don't necessarily look exactly like our subject matter – they may be a bit distorted – but they will have undoubtedly caught something of what we were looking at. It is the most intuitive way of drawing: we are not drawing for the end result, we are drawing to learn or have fun.

In this exercise I want you to pick an object that means something to you. Place it in front of you on white paper. Look carefully at it before you begin. I have chosen a shoe but it could easily be a vase of flowers, a cooking utensil or a tool. Approach the object as you did with the squiggle. To begin, find a long horizontal or diagonal line at

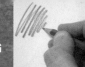

the top of the object. Start drawing with slow pressure and don't stop till you feel it's right to do so. Things to remember:

- Use a pen so you can't erase.
- Draw slowly.
- Use continuous lines.
- Stop when you need to.
- Follow the curves/edges of the object as you see them.
- Draw the bits that are in front first, then the 'under' bits.
- Be aware of the negative spaces that may appear in the object.
- Turn everything into a line, including highlights and shadow edges.
- The little mistakes you make will become part of the final drawing, so keep each one and don't cross it out.

When you're finished, have a good look at your drawing. Enjoy its shape and movement.

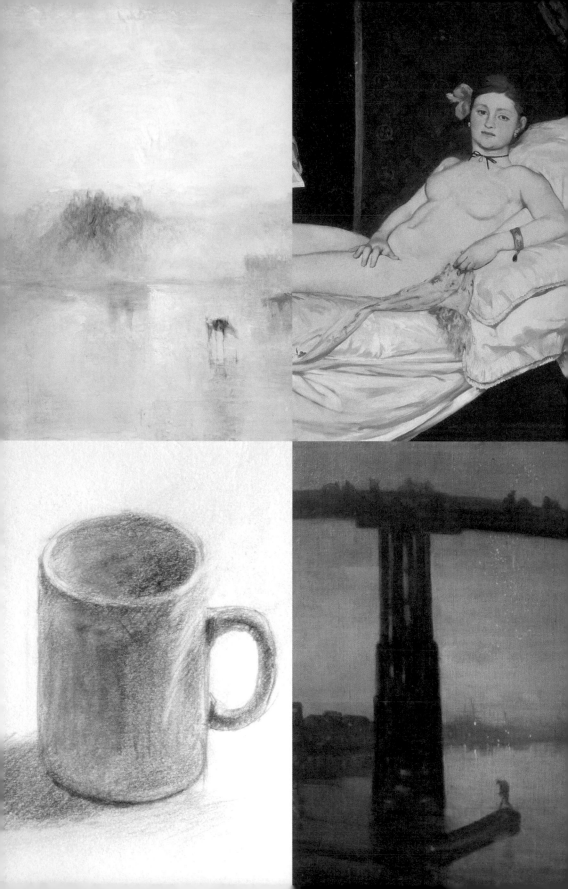

5

Light and dark

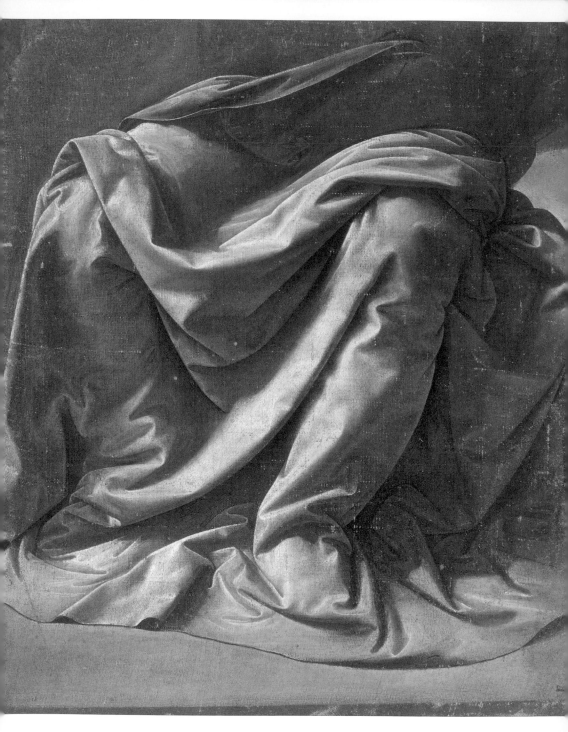

LIGHT AND DARK

We touched on this subject lightly in exercise three when we drew a scroll. Light and dark arc what enable us to give an impression of something being three-dimensional. 'Tone' is another word for how light or dark something is.

Opposite is a magnificent example of the use of light and dark. This is a beautiful tonal study by Leonardo da Vinci of drapery over somebody's legs. A boring subject, you may think, but Leonardo has elevated it to something else. There is a great balance of light and dark in this image. Leonardo doesn't need to draw the person whose legs are being draped for you to get a sense that it is real. It looks so solid, weighted and affected by gravity that it is almost like a statue. It goes to show what you can

HANDY HINT

When you see artists squinting, it's for a reason.
I want you to try something now. Look at the image opposite through squinted eyes. Do you notice anything? You should find that all the subtle detail in the shadowed areas disappear so it just becomes light and dark. This is because when you squint you see the tone of something in its simplest form – the brightest areas and the darkest areas. This is invaluable when you are sketching.

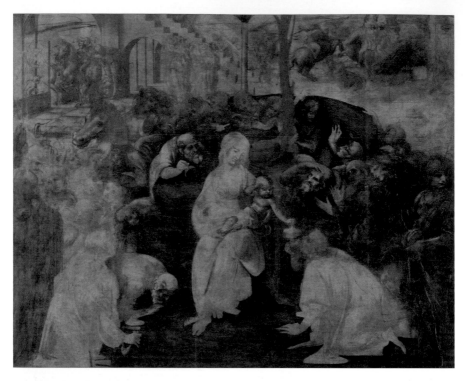

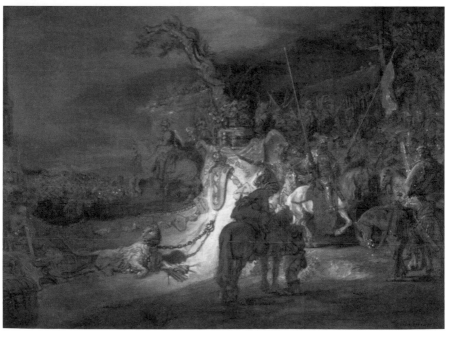

achieve with just two colours. The emphasis here is on tone. Tone is very important in art when you are trying to capture form.

THE IMPORTANCE OF TONE

In days gone by, artists like Leonardo, Rembrandt, Rubens and Vermeer – after doing their initial drawings on to canvas – would do tonal paintings first, like the ones opposite. Once it was dry, they would add colour. The technique of producing these tonal paintings was called 'dead colouring'. It is now referred to as 'underpainting', but to a certain extent this technique has been lost. When the Impressionists came along, they advocated painting colour directly on to canvas.

When works of art are X-rayed now, we can see where the artists may have changed their minds about something – this would have happened in the underpainting stage. By doing the underpainting first, the artist could work out the drawing, the proportion and how light and dark something should be, and so sort out the composition beforehand without having to worry about what was going to happen with the colour. The underpainting was almost like a dry run. Underpainting had other advantages, too: it is believed that artists used

111

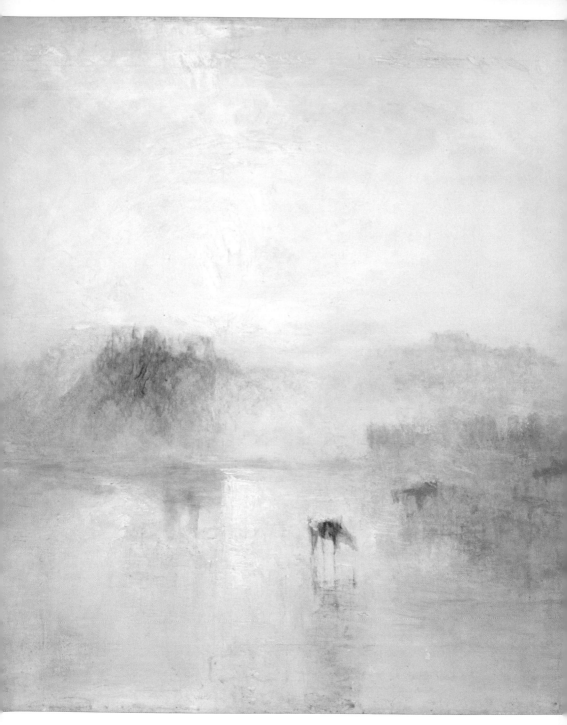

to keep a few underpaintings in their studio to show possible clients before they went ahead with completing the painting.

Eventually, the leanest areas would be the darkest and thickest areas would be the lightest areas. The final effect would be a very rich work of art. Next time you are near an art gallery, go and have a look at a Rembrandt oil painting and see how the fleshy bits are really thick – meaty and marvellous!

LIGHT

'Light is the first of painters. There is no object so foul that intense light will not make it beautiful.'

RALPH WALDO EMERSON

Many artists have been obsessed with capturing the effects of light – artists like Turner with his atmospheric effects (see the picture opposite) and Whistler with his mysterious foggy twilight scenes. Before we sit down to draw or paint something, we have to be aware of where the light is coming from. Light will affect how the shadows of the object fall and the degree of relief (three dimensions) in which a subject appears. Natural lighting is used by most artists – it is essentially one soft light from above. Vermeer

had a studio with windows to the north so that the light didn't change much during the day. When painting outside, the Impressionists had to deal with the harsh effects of direct sunlight, and sculptors who create works to be displayed outside in the open air know full well that nature will add a great deal: with every change of the light their work will appear different, so at dawn or sunset, the sun or moon will give their work another mood or feeling.

If we are lighting the subject matter ourselves, we have to consider what light we want. Light can be used in a picture to draw attention to an aspect of the scene. Some examples of different types of light are as follows:

Backlight

This is the technique of lighting something from behind so it is mainly in shadow. In the picture opposite (picture 1), Rembrandt has strongly lit the centre of the scene to draw your eye to it, whereas the figures in the foreground are backlit.

Natural light

Natural light comes from above. When a face is lit with natural light, the forehead is usually the lightest part of the face – as it is in Leonardo's *Mona Lisa* (opposite, picture 2).

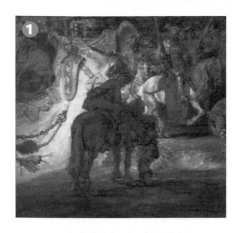

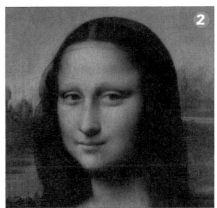

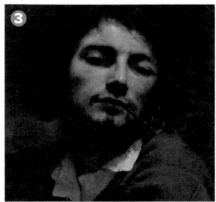

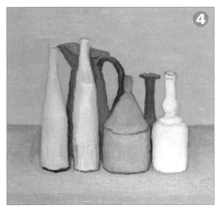

Top light

A spotlight from directly above produces a dramatic effect, as in the picture by Gustave Courbet (picture 3). It makes the eyes fall into shadow and produces high contrast.

Flat light

This is subdued and subtle light where the shadows are minimal and the tones in the picture appear very close, as in this still life by Morandi (picture 4).

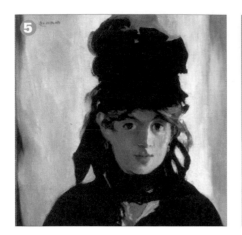

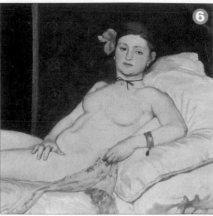

Side light

This is light from the side, as in this picture by Manet (picture 5). Another famous example of side lighting is the photo-graph of the Beatles from *A Hard Day's Night* by Robert Freeman.

Flash or frontal light

This is a harsh lighting effect from the front where the

> ### ARTY FACT
>
> When painting his twilight views of the foggy Thames, Whistler would sit on the banks for hours just observing the dimly lit scene. He would then go back to his studio and paint what he had seen from memory. He believed that this way he would forget things that weren't important. He used decorator's brushes to paint, and his mixed paints were so runny on his palette that he called it his 'sauce'.

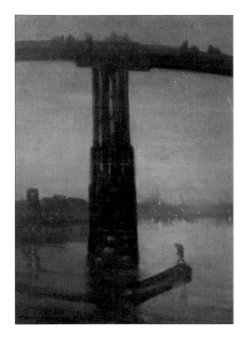

viewer is, as in this picture, also by Manet (picture 6). It has a 'flattening' effect on subject matter.

Minimal light

As in this picture by Whistler (left), paintings made at night or twilight, when the light source is low, convey mystery and mood.

TONAL TRICKS OF THE EYE

Not only can the brain play tricks on us when it comes to the proportion of things like the top of somebody's head (we *think* it's less important so we draw it smaller than it is), it can also play tricks with us when we are looking at the tone of something. That is why we have to look carefully.

If we look at the image overleaf, we perceive square B to be lighter than square A because we believe the illusion of reality that there is a cylinder casting a shadow on a chequerboard. However, as we have already learned, when we start seeing like an artist we should not 'believe' but

117

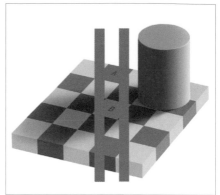

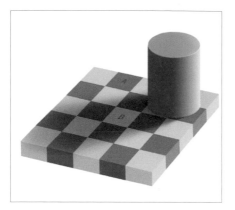

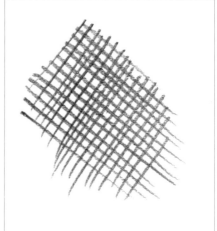

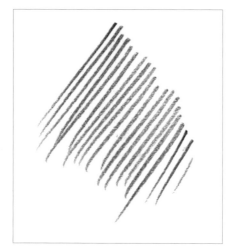

'see'. In fact, square B is exactly the same tone and colour as square A. Look at the image on the previous page.

Part of the reason we make this mistake is because we are looking at the pattern *around* the square: as the squares around square B are darker, it makes square B itself look lighter.

DRAWING TONE WITH A PENCIL

To give something tone with a pencil we shade it in, much as we did with the scroll in exercise three. By shading something in, we are making it look three-dimensional.

When we shade with a pencil, we do it with a series of short, light lines. This is called 'hatching'.

When we do lines criss-crossing each other, it is called 'cross-hatching'.

For added dimension you can even make these lines follow the form of the object. If you would like to make something darker, you can just add another set of hatches over the ones you have already done. You can also soften the effects of hatching by smudging with your finger or eraser.

HANDY HINT

To make something look lighter, draw the surrounding areas darker. To make something look darker, leave the surrounding areas lighter.

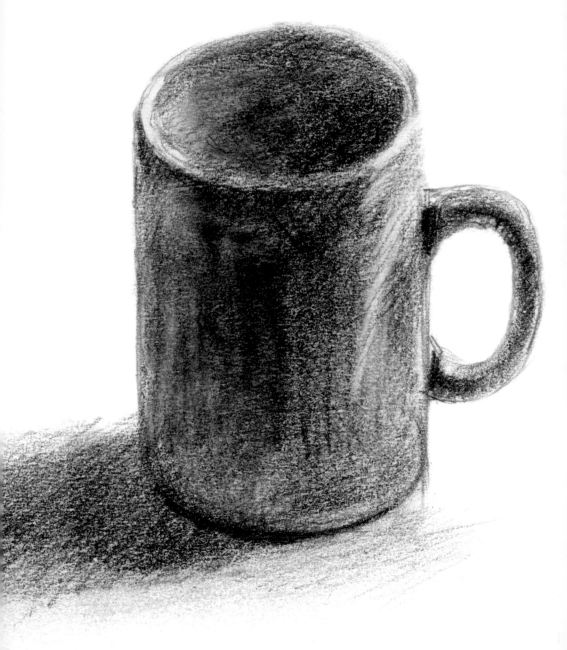

Exercise Fifteen: Pencil Study of a Mug

As an introduction to tone and light and dark, we are going to draw a mug in pencil. With this exercise we are going to look at the basic shape of a mug and draw a foundation line drawing of it, breaking it into its basic shapes. Then we are going to shade it in so that we have an illusion of three dimensions.

You will need some paper, a 2B pencil, an HB pencil and an eraser. Find a plain, pale-coloured mug and place it in an area where the light is coming from the left-hand side – perhaps near a window.

Step one

Take your HB pencil and draw the basic shapes of the mug first. Draw a vertical line down the middle of your paper, parallel with its vertical edges. This will be the centre of the mug. Look at the mug to see where the top and bottom of it are, and place two marks on the line you have drawn to indicate these points on your paper. Measure where the lip of the mug appears and mark this on your drawing too.

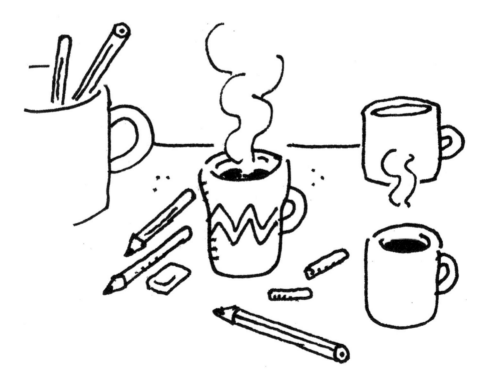

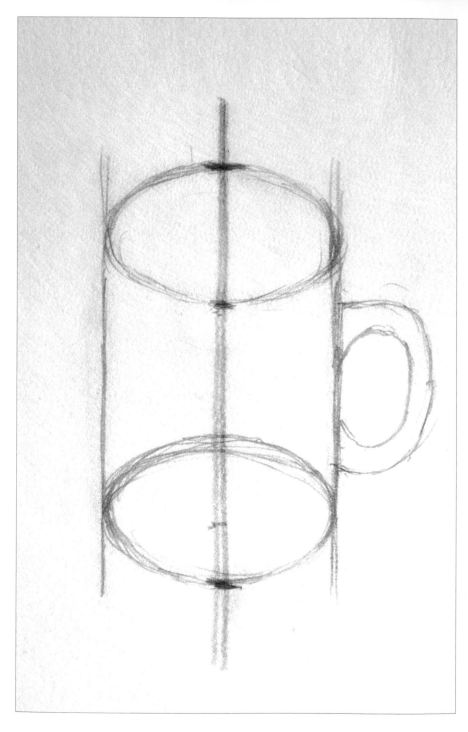

Step two

Look at the oval shape at the top of the mug and draw it in on your paper. Draw the same shape at the bottom of your line. Now draw in the sides of the mug – they should be parallel with the vertical central line and the edges of your paper. Draw in the handle loosely on the right-hand side of the mug. You now have the 'skeleton'; the next step is to make it look three-dimensional.

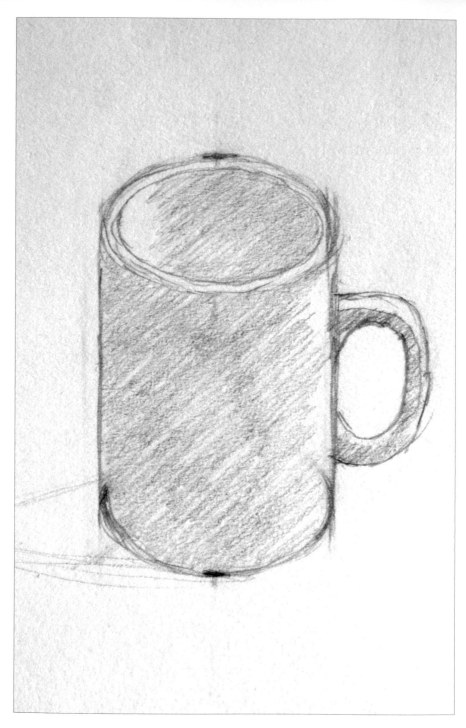

Step three

Erase the main central vertical line and the oval at the bottom. Now squint at the mug. Look for the lightest area of the scene, and the darkest area. With light pressure of your pencil, apply a light tone to the whole of the mug except for the lightest areas, which we will leave as the white of the paper. You can use an HB pencil for this. Now look at the mug again to see where the mid-tone areas are, and hatch them in.

HANDY HINT

If you want to assess just how dark or light something really is, hold up a piece of white paper to the scene in front of you. If you think of the white paper as the white of your drawing paper or canvas, you can then see just how dark or light something is in comparison to it. This is a particularly useful technique for gauging skin tones. It will help you keep the contrast of your drawing or painting in balance so the whole picture doesn't get too dark or light all over.

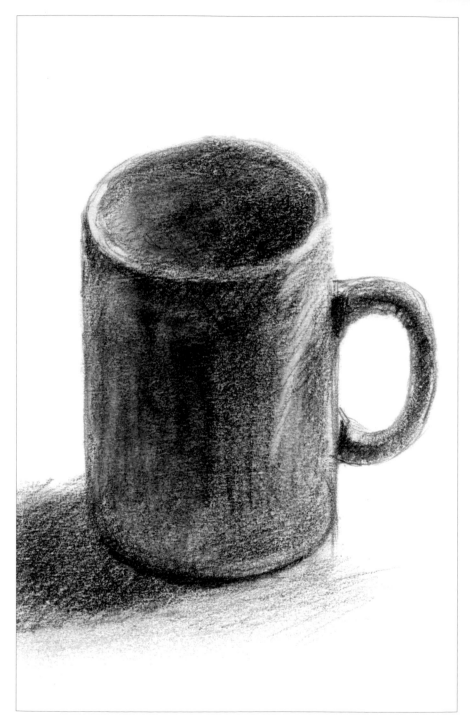

Step four

Using a 2B pencil, shadow in the darkest areas of the mug on the edge and graduate these dark areas into the mid-tone. Place a dark line where the mug touches the surface it is sitting on. Finally, add the shadow of the mug to 'ground' it.

If you want to 'set off' the lightest area of the mug, you can shade in the background behind it to make the lightest bit stand out even more. When you've finished, take a look at your work from a distance and admire your first tonal pencil drawing from life.

HANDY HINT

When drawing or painting, it is important to take a step back and look at your work from a distance. This lets you see your work in perspective. When you are working on something, it is quite easy to 'lose yourself' and end up with your nose almost touching the paper. When this happens put your pencil or brush down, go and make a cup of tea, then view your work from a distance as if you are looking at someone else's picture. It is the same as looking at it with a fresh pair of eyes.

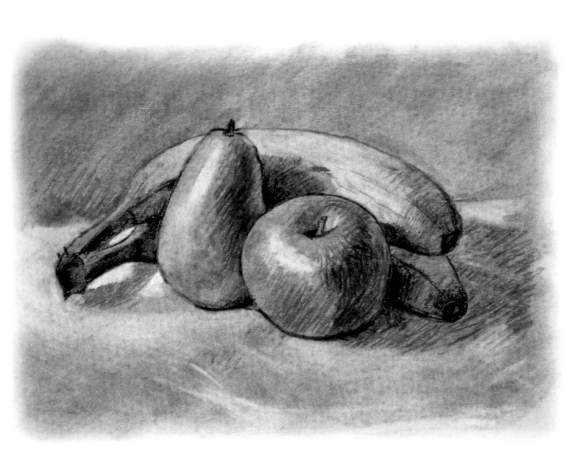

Exercise Sixteen: Charcoal Still Life

In this exercise we will be drawing in charcoal a still life of fruit with a strong side light. We will cover the paper with a charcoal mid-ground, so it will be similar to the way artists of the past did their tonal paintings. In this case, we won't be using white paint to depict the brightest bits, we will be using the eraser to rub out the charcoal and expose the white of the paper.

I have chosen charcoal for this exercise because I think that, if you can master the basic principles using charcoal, you can quite easily progress to paint. Charcoal, like paint, is easily adjustable.

Portrait Format

Landscape Format

Arrange the fruit in a way that pleases you, and use a small desk lamp to light the fruit from the right-hand side.

Step one

Turn the pad round so that it is landscape format (wide rather than tall). Draw a rectangle on your paper, then fill it lightly with your charcoal by turning the stick on its side and gently shading it. Once you have done this, look at the fruit in front of you and draw in their main outlines.

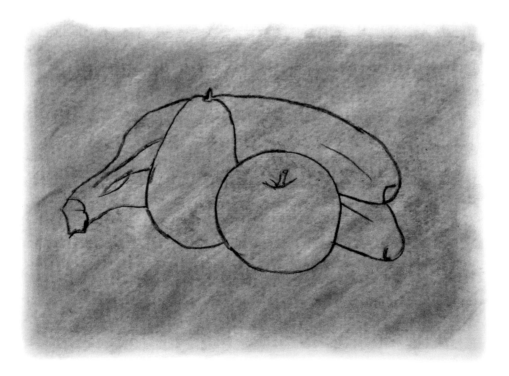

Step two

Look at the scene in front of you for tonal values. To do this, squint at what you are looking at. Look for the lightest areas of the scene. Look not only at the fruit, but also at what is in the background. Be aware of the negative spaces surrounding the fruit, as these are going to help you measure things and get the proportion right. Where are the lightest areas? It will probably be where the light from the desk lamp is hitting the side of the fruit.

Now take your eraser and rub out the lightest areas on

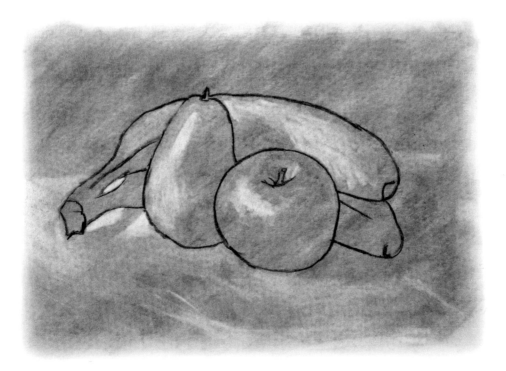

your paper. The white of the paper should come through. Rub out all the light areas in the scene, including anything behind the fruit that is light where the fruit is silhouetted.

Step three

Look at the scene again through squinted eyes. I want you to look for the darkest areas now, where the fruit is in shade. Fill in these areas with your charcoal. You can then use your finger to smudge the darker areas into the mid-tones of the ground.

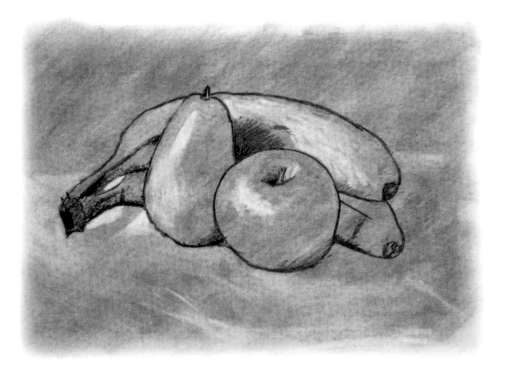

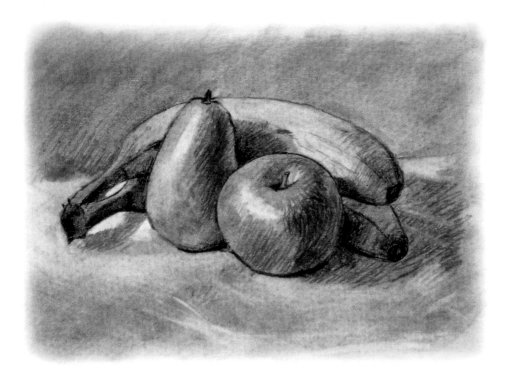

Step four

Now put the mid-tones in, and any shadows that occur in the scene. Erase any heavy outlines that aren't needed. Step back and admire your first charcoal still life!

If you try this exercise again, swap the fruit for other simple objects. Follow the steps in the same way, but at step one, try not to use any outlines. Instead, depict the forms of the objects with blocks of light using your charcoal and eraser. If one of the objects is in shadow, erase the background/negative space behind to make the form appear. Only put in contours (lines) where necessary.

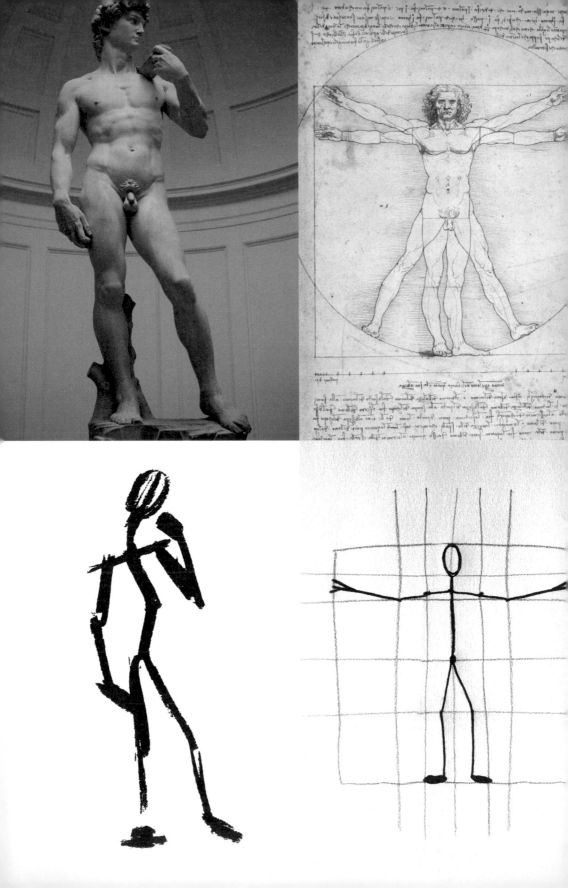

6

The human figure

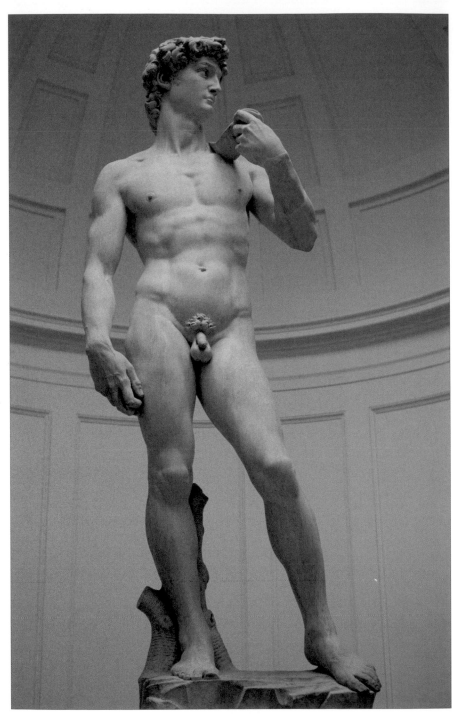

THE HUMAN FIGURE

Throughout the ages, artists have turned to the human figure as a source of inspiration. In the nineteenth century, students would learn to draw from casts of Classical Greek statues. The human figure is great subject matter if you want to learn the principles of drawing, as there are so many things to consider when drawing it. In the next few pages, we are going to address some of the ways we can look at the human figure and make it easier to draw.

If I were to tell you to draw a man, what would you do? You would probably draw a stick man. Take your pencil or pen and draw one now if you like.

I have told you previously to draw what you see but when it comes to the human figure it is easy to draw things out of proportion. I will show you a way of drawing a stick man that will teach you about the proportions of the human body. This will help when you next come to draw a full figure.

ARTY FACT

The proportions of Michelangelo's *David* (opposite) are not quite true to human form – the upper body and head are actually bigger than they should be. It is presumed that this was because the statue was designed to be viewed from below, in which case the proportions would appear correct.

Exercise Seventeen: How to Draw a Stick Man

Draw a box. Split it in half horizontally then vertically. Now split each row and column in half again. Split the upper-most row again in half horizontally. Split the middle two columns in half again.

In the middle of the box, draw a small dot. This is the pelvis. This is the exact centre point of the human figure.

Let's draw the left upper leg. From the pelvis, on the left and at a slight angle outwards, draw a line down and

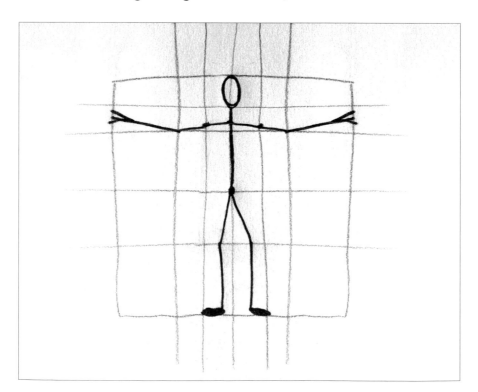

stop at the line of the first box. This is where the knee joint is. Now let's draw the left lower leg. Drop a line down vertically to the edge of the box. Now draw a foot here, ending at the first vertical line. Repeat this for the right leg.

We've drawn the lower half of the body; now for the upper part. Let's draw the head. Draw an egg shape in the uppermost row. It should be roughly an eighth of the size of the figure. Drop a line down the middle from the bottom of the head to the pelvis. This is our neck and spine.

Finally, we will add the shoulders, arms and hands. A little way down the line below the head, draw a dot on the spine. This is where the neck meets the spine. Let's draw the left shoulder. From the neck dot, draw a line out at a slight angle downwards to the next line. Stop here. This is the shoulder. To draw the upper arm, carry the line on in the same direction and stop at the next grid intersection. This is the elbow. Draw a line from the

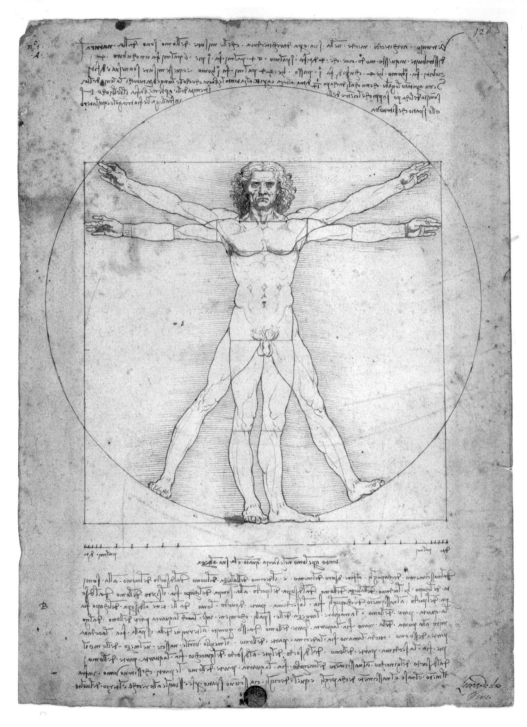

elbow slightly upwards to the outside of the box on the left. Then draw a hand. Repeat this on the right-hand side.

You have drawn a stick man in roughly the right proportions of the human figure. Think of the main stick lines as the skeleton of the human being and you won't go far wrong.

See the facing page to discover who worked this out ... opposite is Leonardo's drawing of 'Vitruvian Man'. Leonardo believed that 'man is the model of the world'. He believed that there was an inherent symmetry in everything we see – particularly the human figure.

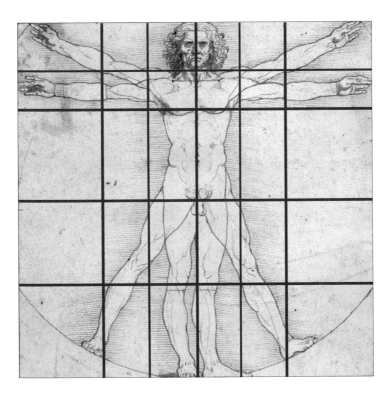

He shared many of the ideas expounded by the Roman architect Vitruvius, who believed that these principles of symmetry could be applied to architecture.

If we superimpose the stick man's grid over this drawing, we can see how it is basically the same idea.

If you look at this image, you will see that the height of the man is equivalent to the length of his outstretched arms. Not only that, but, if we use a circle in the image, the outstretched arms and legs touch the edge of the circle, with its exact middle being the belly button.

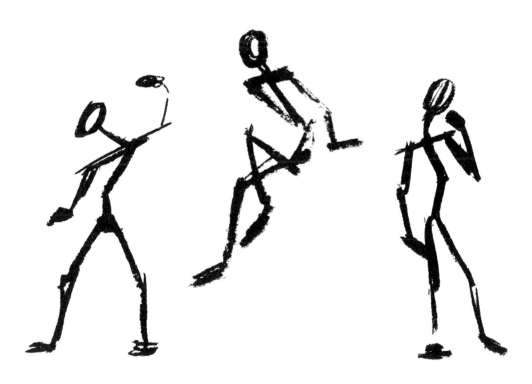

Exercise Eighteen: Quick Drawing

Knowing what you know now about the basic proportions of the human figure in stick-man terms, you can apply this to your next exercise and put it into action with quick drawing.

Get a friend to pose sitting with their hand on their chin or in a position that involves some angles. Quickly try and get down the essence of the pose in two minutes. If you don't have anyone to pose for you, look at any full-length pictures of people doing something and try to get the 'essence' of their pose in two minutes.

This exercise forces you to lose extraneous detail and get to the bones of the matter. When you are drawing, think stick man – there is no need for detail with this exercise. It's about gesture and movement and summing something up quickly.

THE LINE OF ACTION

In the world of animation there is a concept known as the line of action. This is the overall line of somebody's pose. The stronger the line of action, the more dynamic and effective the pose. If you look at the figures opposite, you can see the line of action is clear and the poses are stronger because of

it. When animators are trained they have to do what is known as a cycle – somebody going through the motions of an action. Have a look at the figures below.

We see a figure picking up a heavy ball. Animation calls for exaggeration of pose. Can you spot the state with the clearest line of action in this cycle? It is the third figure along. When the figure is straining to hold up the heavy object, the line of action is clearest.

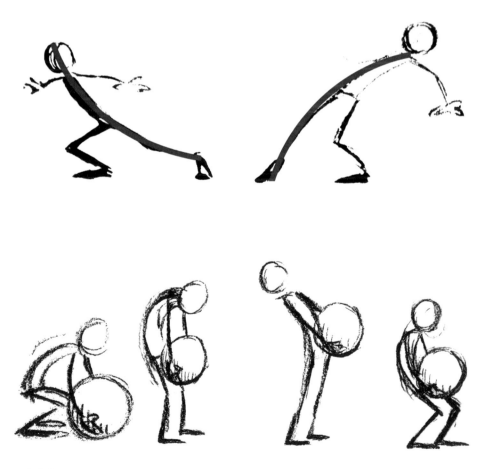

When we draw people in everyday circumstances, their poses may not be as extreme as this, but the principle is worth noting when capturing action, rhythm or movement.

THE LINE OF WEIGHT

Overleaf is a sculpture by Edward Degas of a dancer looking at the sole of her right foot. Over it I have drawn a red line. This represents the 'line of weight'. The line of weight replicates the effects of gravity on the figure in the picture plane.

No matter what the position of the figure, extreme or static, you should be able to drop a vertical line down the middle of the pose to the ground and see that on both sides of the line there is an equal amount of the body. It is a line of balance and stops the figure 'falling over'. The only time people are off balance is when they are going so fast that to stop suddenly would mean they would fall over. Most poses are not as active as this, so the line of weight applies. In painting, this line only has to apply to one angle, that of the viewer to the picture, but in sculpture, as in real life, it has to apply from every single angle!

INACTIVE AND ACTIVE LINES

If you look at the Degas sculpture again, you will observe there are two blue lines on either side of the figure. The blue line on the left-hand side is the active line where the masses of the body twist and turn and where the angles are sharp and clear. The right-hand side is the inactive side which is smoother but also has grace and subtlety. The two lines live in harmony with each other. Bear this in mind whenever you draw a figure in a twisting pose. On your paper, mark the top of the head first, then the feet. Start at the head and draw the active line down first, sketching in the angles of body masses. Then draw the inactive side. Take a look at Michelangelo's *David* again on page 138. David's pose is *contrapposto*. This was an artist's technique that posed the human figure with its hips and legs turned in a different direction to the rest of the body on the vertical axis. It helps to illustrate the natural counterbalance of the human figure. Can you see where the active and inactive lines occur?

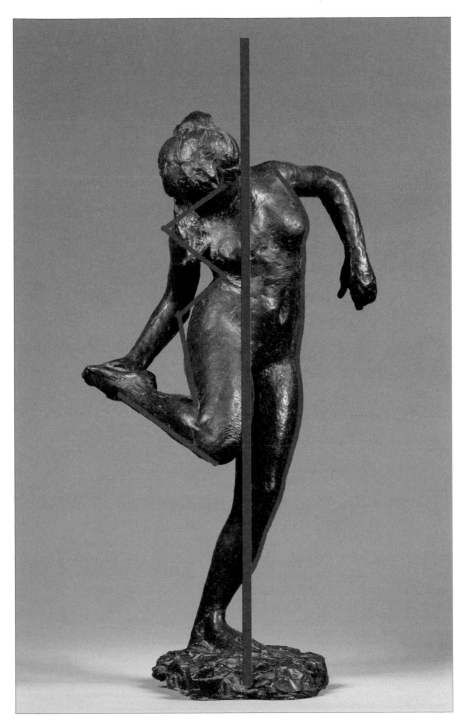

Exercise Nineteen: Life Drawing

The next exercise is life drawing, something that every serious art student and practising artist should do on a regular basis. My advice would be to find out where your nearest life-drawing class is but, as this may not be possible for everybody, I have provided some reference for you to practise from.

Opposite is a photograph of Wayne Sleep. Wayne, a record-breaking dancer, has been a model for David Hockney in the past, and he very kindly agreed to pose for me for this book. The pose he assumes is the classic ballet posture the Arabesque.

Dynamic posture is a prerequisite for dancers. Certain poses require the dancer almost to defy gravity. Life drawing is all about capturing the rhythm and movement inherent in the human body, so here we have a good pose to draw from. Take your charcoal or pencil. Mark where the top of the head is, and the foot on the floor. Indicate the line of weight with a vertical sweep of your pencil (remember, this is a vertical line down the centre of the page that divides the bulk of the body in two). Then, from the head to the outstretched toe, indicate the line of action with a broad sweep. As there isn't much

150

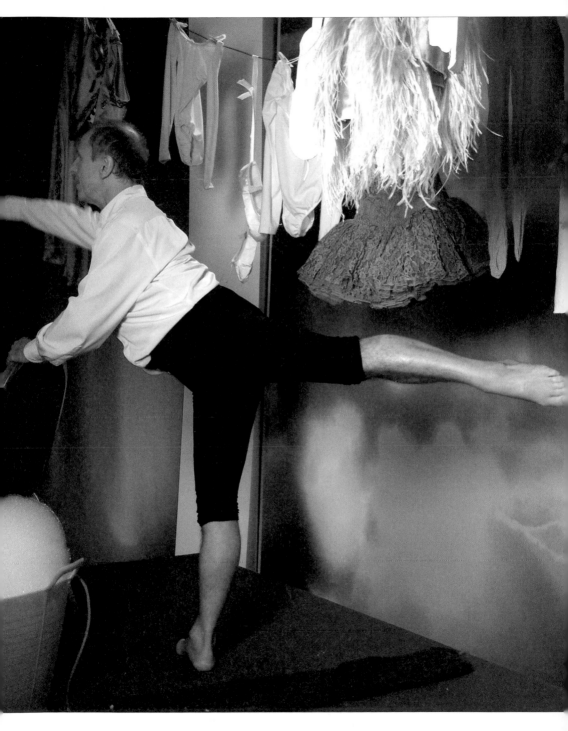

twisting in this pose, the thing to concentrate on is the balance. The challenge is to avoid making the figure look like it's falling over.

If you want, you can use the negative shapes behind the figure to help get the proportions right. The central column behind the dancer provides a good natural line of weight and allows you to see the negative shapes behind the thigh. You can measure too. For instance, note where the top of the chair is in comparison to the waist.

Remember that the pelvis is the middle of the figure and that the legs and top of the body should be of roughly equal proportions – although there is some fore-shortening in the legs as they are nearer to the viewer.

We don't want a masterpiece here – just a sketch to show you are getting the grasp of what a drawn figure should look like.

Exercise Twenty: How to Draw a Face

Opposite is a simple image of a face. We have already drawn David Beckham; now we are going to learn a lesson about the basic proportions of the human face.

The proportions of anything are a bit like the hopscotch grid a child draws on the pavement. As long as you have

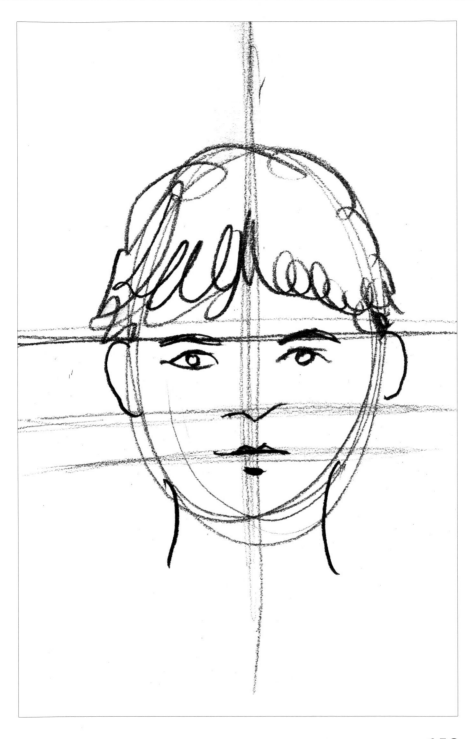

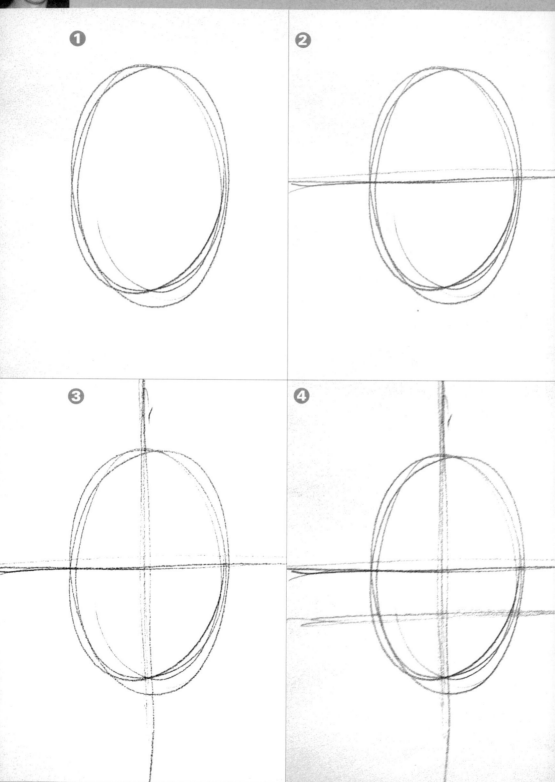

the basic structure of the grid on the ground, you can innovate as many different types of jumps as you like within it. When you get familiar with these facial proportions, you will know what to do when you want to draw or paint a self-portrait or a portrait of somebody you know. You will have the correct foundation, scaffolding or skeleton to build with.

Step one
Draw an egg shape for the head.

Step two
Split it in half horizontally.

Step three
Split it in half vertically.

Step four
Split the lower half of the egg in half horizontally.
Now, before you turn the page over, where do you think the eyes will appear? Turn over to find out.

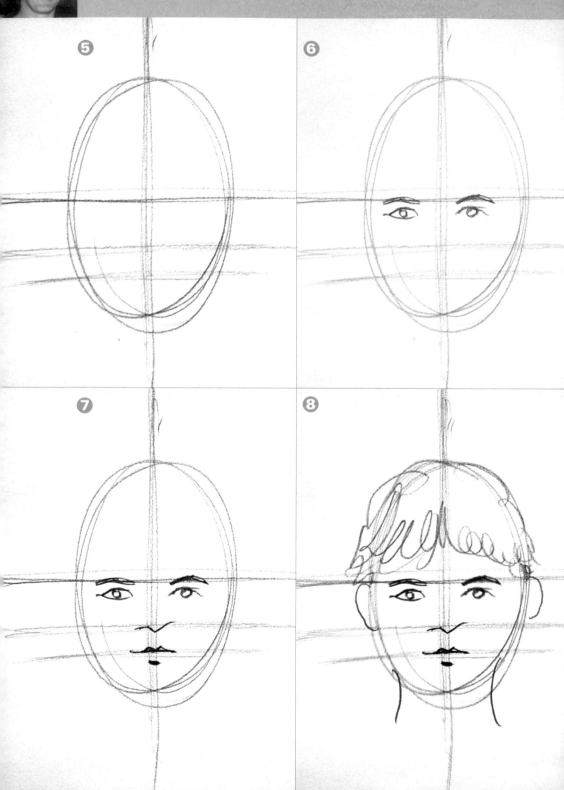

Look at the drawing for step six. Are the eyes where you thought? Eyes normally appear halfway down the skull.

Step five

Split the lower half of the egg in half again horizontally.

Step six

Add the eyebrows on the halfway line, then draw in the eyes immediately below them. Make the eyes almond-shaped with a circle in the middle loosely shaded in to suggest the iris. Try to mirror where the eyes appear relative to each other.

Step seven

Draw the nose in on the next line. A shallow U shape will do to suggest this.

Step eight

Add the shadow of the top lip on the next line, and a little dash of dark underneath to represent the shadow of the bottom lip.

Congratulations! You have drawn a human head with the correct proportions. Remember these proportions when you next draw somebody or yourself, and see the difference in your work.

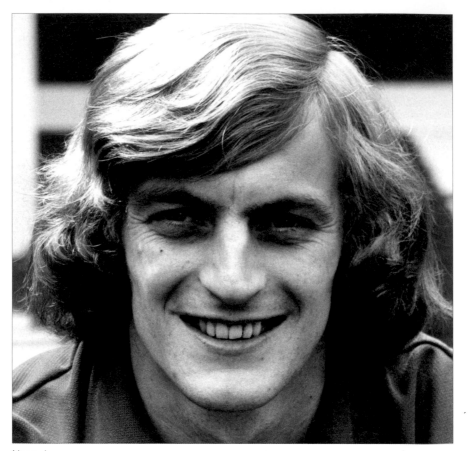

Normal

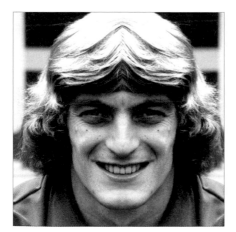

Right side mirrored

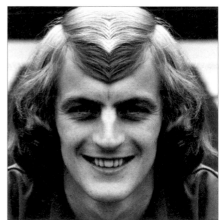

Left side mirrored

THE FACE

Of course, not everybody's face is the same. Nobody's face is perfectly symmetrical – not even David Beckham, although it does come close. This is what makes everybody unique. To illustrate what I am talking about, let's look at a footballer from yesteryear, Paddy Roche (opposite).

If we mirror different sides of the face as I've done here, we can see the obvious differences in the balance of proportions. On his right side, Paddy's eyes are more hooded; on his left side, his nose is flatter and the face narrower.

Next time you look in the mirror, remember that this is not how you actually appear. The image you see is flipped horizontally. To see what you really look like you need two mirrors, a photograph of yourself or, better still, a portrait! I have a portrait-artist friend who painted a lady's portrait. She wasn't happy with the result. He went back and worked on it several times, and each time she wasn't happy and said she didn't recognise herself. He then realised that it may have been because she wasn't looking at a mirror image of herself, so he took a photograph of her at the next sitting, developed it the wrong way round and painted her portrait from that. When he next took the portrait for her approval, she loved it!

159

Above and opposite are images of two comedians, Ben Stiller and Ricky Gervais.

They have completely different faces and head sizes. Ben (above) has a big face/head; Ricky (opposite) has a small face/head. Ben's features are spread over his face; Ricky's features are a bit squashed up in the middle. (Sorry, Ricky!) They are both unique.

We just learned about the proportions of the human face, however, and, even though these two people look

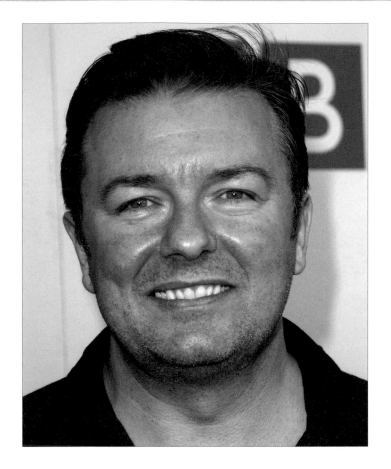

completely different to each other, we can actually apply the same principles of proportion to both faces. Even though Ricky is tilting his head upwards slightly, in both cases the eyes appear roughly halfway down the head, the bottom of the nose is in line with the bottom of the ears and so on.

For our next exercise we can see how these guides to proportion can apply to the side view of a head.

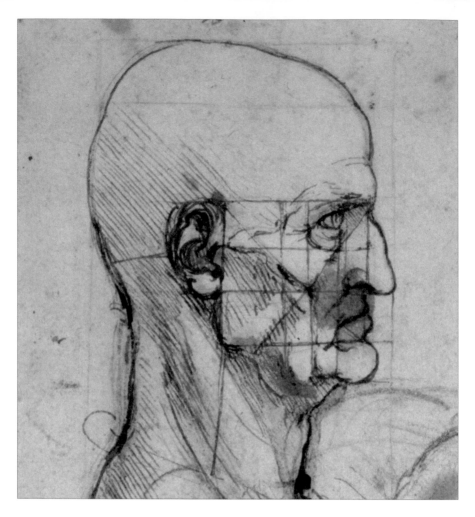

Exercise Twenty-one: How to Draw a Side Portrait

As you can see from the drawing above by Leonardo, the proportions of the human face have fascinated artists for centuries. Note how Leonardo's drawing confirms that the brow is in line with the top of the ears and the bottom

of the nose is in line with the bottom of the ears. And, just like in our drawing of David Beckham, Leonardo has used a square shape.

We are going to start our drawing with an egg shape again to represent the whole head in its simplest form.

Step one

Have a look at the images overleaf. Loosely and lightly draw a sweeping diagonal line across your paper in the direction indicated in the picture overleaf. Now draw a tilted egg shape using the diagonal line as its axis.

Step two

Split the egg in half horizontally, and loosely draw in a neck.

ARTY FACT

The story goes that Michelangelo was commissioned to sculpt a huge figure of his patron Pope Julius. The pair quite often did not see eye to eye. Work began but the Pope was not happy with the size of his nose and requested the artist to modify it. Michelangelo, resentful of interference, took a handful of dust and his chisel and went back up the ladder. As he pretended to chip away at the nose, he let the dust in his hand fall. 'How's that, your Eminence?' he asked. The Pope looked up at the nose and replied, 'That's much better.'

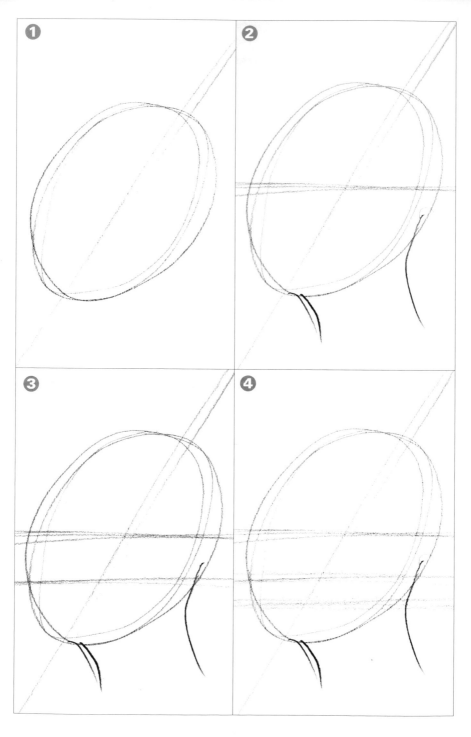

Step three

Split the lower half of the egg in half horizontally.

Step four

Split the lower quarter of the egg in half again horizontally. Go over your lines to reconfirm they are in the right place if necessary.

Step five

Above the halfway line add a brow. Underneath the halfway line, and ending at the next line, draw a nose.

Step six

Draw a top lip ending at the third line you drew. Draw in a lower lip. The mouth should be where the third line is, just as it was with the front face drawing. Draw in a chin. The bottom of the chin should be in line with the bottom of the egg shape.

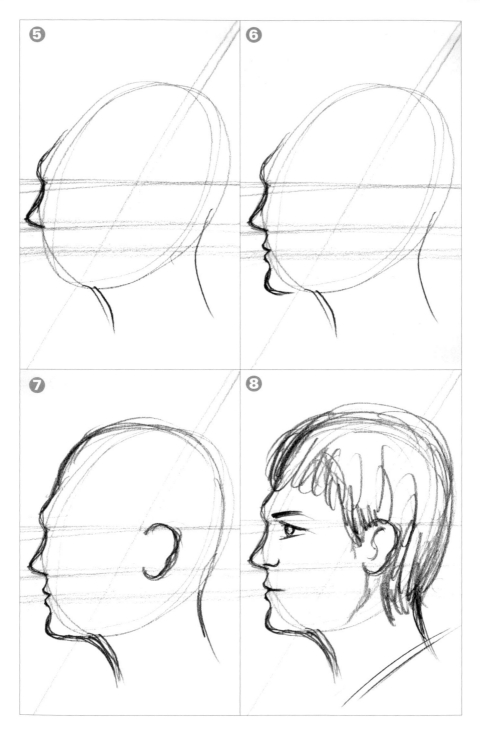

Step seven

Now let's round up the head a bit to make it less egg-shaped. Draw in a forehead, rounding it over the whole head to reconfirm the shape of the skull. Bring the chin to the neck. Reconfirm the lines. Where the original diagonal line crosses the halfway line, start drawing an ear. The ear begins at the brow line and ends at the nose just like Leonardo's drawing.

Step eight

Now draw in the suggestion of a jaw coming down from the ear. Add the eyebrow just above the halfway line and the eye just below it. Loosely suggest the shell of the inner ear, and finally draw in the hair using the hair line in the picture as a guide.

Congratulations! You have drawn a human head from the side with the correct proportions. Bear these proportions in mind when you next draw somebody – or yourself – and you'll see an immediate difference in your work.

HOW TO DRAW AN EYE

One of the common errors people make when drawing or painting eyes is making them look like the one below, on the left-hand side.

I call it 'scary-eye syndrome'. You will rarely see this much of the white of anyone's eye unless they are in a state of surprise or shock. I believe people draw eyes like this because they are relying on their memory of the eye symbol instead of actually observing an eye.

Another common mistake is to draw the eyes too big. This happens because we think the eyes are more important, so we draw them bigger.

The eye is more likely to look like the one below, right.

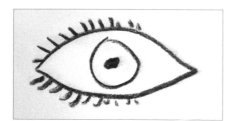 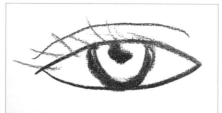

HANDY HINT

Opposite (above right) is Vermeer's famous portrait *Girl with a Pearl Earring*. This is what's called a three-quarter view – somewhere in between the frontal and the side view. Now, look in a mirror and turn your head to the side as in this picture. One part of the white of the eye disappears. The angle of your head can alter how your eye can appear.

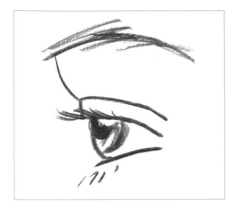

The lid of the eye comes over the iris and only the lower part of the iris is visible.

Try looking at someone's eye from the side (above, left). You will see the heaviness of the eyelid – it comes out and over the ball of the eye.

If you have trouble drawing somebody's iris, concentrate on getting the shape of the white of the eye right. Think of it as negative space.

HANDY HINT

Look at your own eye. We look at ourselves every day in the mirror. If you are a woman, you look when you do your make-up; if you are a man, when you are shaving; if you are a teenager, when you are squeezing your spots! Next time you look in the mirror, really look at your eye. Keep looking at it while you rotate your head forward so that your chin touches your chest: you will see more of the lower white of your eye. Nobody's eyes are exactly the same. See if you can spot the differences between your own eyes.

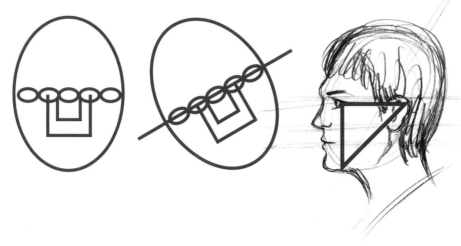

THE FEATURES

The diagram above may look a bit freaky, but it actually illustrates the basic symmetry of the human face.

- The width of the face is five times the width of the eye.
- The distance between the eyes, where the bridge of the nose is, is one eye's length across.
- If you drop a line down from the inner corner of the eyes on both sides of the nose, you get the width of the nose.
- If you drop lines down from the pupils of the eye, they fall either side of the edges of the mouth. Most mouths are actually not this wide.
- If the head tilts or turns, the central axis of everything in the face turns with it.
- When looking at the side of somebody's head, the distance from the eye to the back of the ear is roughly the same as the distance from the eye to the chin.

Exercise Twenty-two: Draw a Self-portrait

This exercise should be the culmination of all you have learned in the book. Prepare your paper in the way that you prepared for the charcoal still life, by putting a ground on it in charcoal. Lightly draw in crosshairs (see page 154).

Sit in front of a mirror with a lamp to the side of you. You should be at arm's length from the mirror – adjust it so that you can comfortably see yourself. Make sure your pencils, charcoal and eraser are near you on a table so you don't have to move too much. Adjust the lamp so the light hits your face. Move your head around until you find an angle you like. Compose your head in the mirror. Keep still and begin.

Look at your face. Look at the negative spaces around it. Look at yourself as an object. Suppress all words.

HANDY HINT

Don't forget the size of the skull. We perceive the face to be more important than the rest of the head, so we draw it bigger and don't draw the skull as big as it actually is. Portrait drawing is just like drawing an apple on a table. It's only because our embedded symbol system is stronger with the features of somebody's face that we have more 'seeing' and less 'remembering' to do.

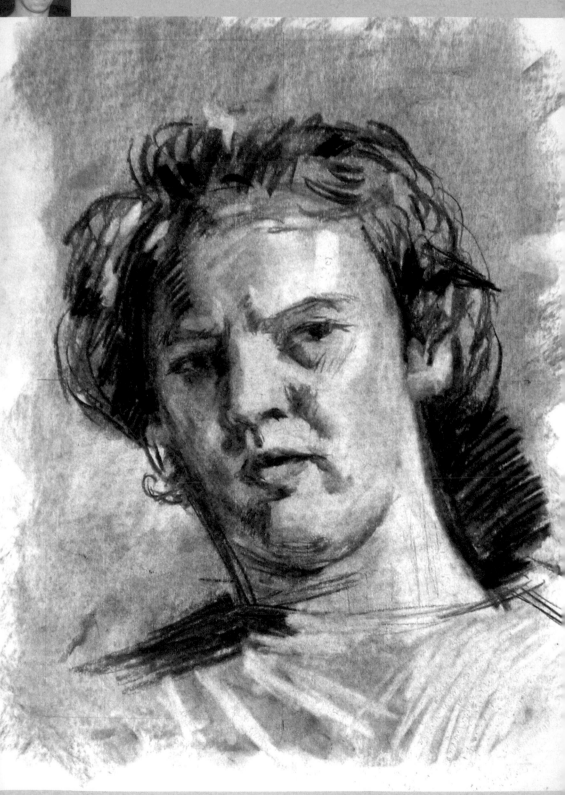

Draw in the central axis of your head. Draw in the central axis of your eyes. These lines should cross at right angles. If your head is tilted, note this tilt. Put your forefinger on the mirror where the top of your forehead is and your thumb where your chin is. Transfer this measurement to your paper.

Next, with your finger and thumb on the mirror, measure the distance from your forehead to the top of your head and note this on your paper, then do the same for the measurement from your forehead to your eyebrow. Get the basic measurements on the paper of where your nose, mouth and ear appear.

Squint at your reflection and erase the largest, lightest areas of your face and the negative area behind it. Forget about features at this stage. If you want, you can smudge in where your eyes are with your thumb. When drawing the hair, all you have to do is put the highlight in where the light hits the hair. Look for the darkest areas and put them in. Remember about the axis of the head, the basic proportions of the face and the symmetry within the features. Define the features only when you have got all the masses of light and dark in the right place. Only draw what you see!

Once you've finished, step back and look at your work.

173

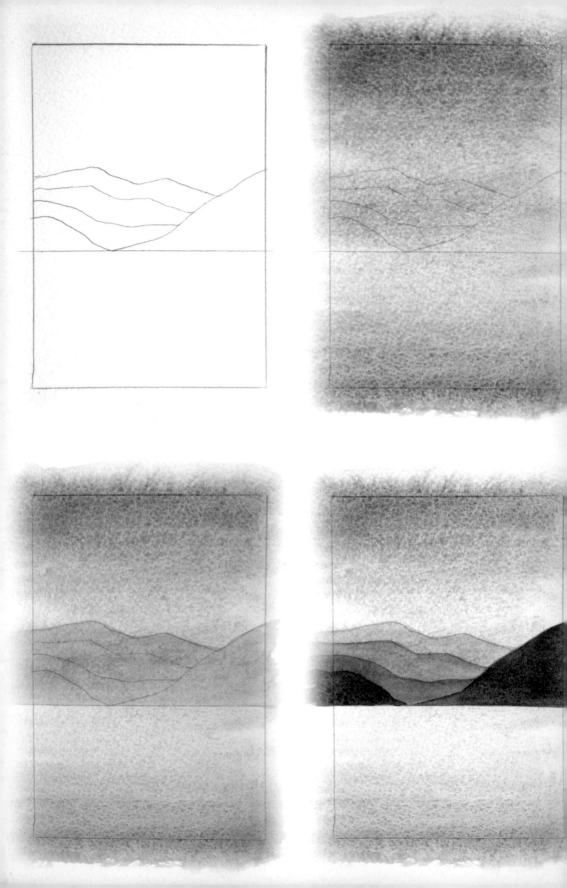

7

Painting

PAINTING

COLOURS

The theory goes that, if you are designing a brand logo, it should work in just two colours first: black and white. If you can't get it to work in black and white, it won't be as strong. It just goes to show how powerful black and white, or high-contrast, images can be when you are drawing. Even babies respond to high-contrast black and white images. The Victorian artist Aubrey Beardsley created wonderfully balanced illustrations in black and white (see opposite page, above), and paintings can be made in shades of grey out of black and white – this method is called grisaille.

Opposite, below, are some high-contrast 'pop art'-style paintings. First we see them as a pattern, then the right side of the brain fills in the gaps and we read them as recognisable people. Black and white can also be added to pure colours to make them lighter or darker in tone.

The abstract expressionist Franz Kline painted large striking 'gestural' paintings in black and white, and Japanese woodblock artists use large areas of black in their otherwise colourful pictures to ground them.

But most painters, of course, want to work with colour.

In theory, you could begin painting with only three colours in your palette: red, yellow and blue. Add black and white for variations in tone and that leaves you with five. Red, yellow and blue are what are known as primary colours. They are the basic components of every colour we see.

Below you will see an image of a colour wheel.

Warm colours

On the left are the warm colours. These are used for objects that are in the light. Warm colours make objects appear nearer to the viewer.

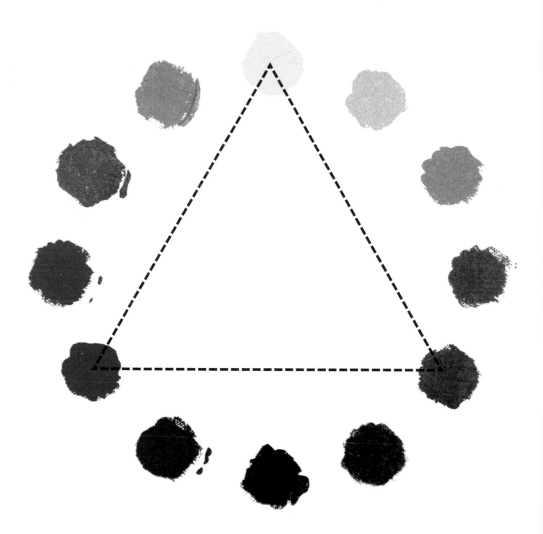

HANDY HINT

When painting, try balancing all your colours just as you would with light and dark. If you use a green, use a red somewhere to counteract its effect.

Cool colours

On the right of the wheel are the cool colours. These are used for objects that are in the shade or distance. They make objects appear further from the viewer.

Colour mixing

If we placed yellow, red and blue out on a palette in a triangular formation similar to the configuration opposite, we could mix all the colours in between them and end up with the colours you see on the colour wheel opposite.

Complementary colours

In art, complementary colours are the opposite of one another.

If we look at the opposite to each colour in the wheel, we will find that colour's complementary colour. For example:

- Yellow and violet are complementary
- Red and green are complementary
- Blue and orange are complementary

HANDY HINT

When painting, instead of using black and white to make a grey, try mixing two complementary colours together and add white to make a subtler grey.

Exercise Twenty-three: Paint a Still Life in Acrylic

For this exercise you will need paint that is quite thick, so acrylic or oil paint should be used if possible. You have already drawn a side-lit still life using charcoal; now I would like you to paint a still life of fruit with flat, natural lighting. This is an exercise in economy. If you look at the painting on opposite, above, by Morandi, you can see that the artist has used flat areas of colour to denote the sides, or 'planes', of the objects. There are hardly any shadows in the scene, but the objects sit convincingly because they have been observed so well.

If you look at the painting of the fruit (by the author), you will see that each fruit has been painted in one colour only. If you look at the black and white image of the same painting, you will see that the tones of the fruit are *very close*. The idea of this exercise is to get the tone and colour of each fruit in one colour. Think of capturing the 'essence' of each fruit in one colour.

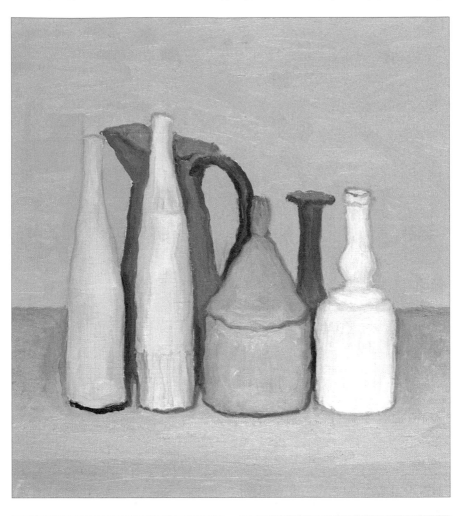

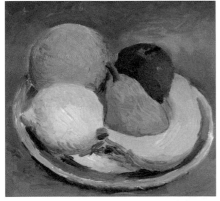

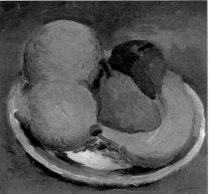

You can give your canvas a mid-ground – which will need to be dry – or you can paint directly on to the white. First of all, draw all the fruit in with a pencil or brush in one colour. Be aware of the composition and negative space. Then choose your first fruit to paint. If you look at the orange and paint this first, squint to observe how light or dark it is. Hold up some white paper to help gauge its tone, and hold your brush up to the fruit with the paint on it to get as accurate a colour match as you can. Then you need to mix a colour up that is exactly the same. Take your base colour, the orange, and add white or a darker colour to it to get the same tone. You will know with the first dab on the canvas whether or not your colour is right. If it sits well with the background of the blank canvas, you have succeeded.

PAINTING IN WATERCOLOUR

Watercolour is a completely different medium from oils or acrylic. If you want to erase mistakes in watercolours, you have to sponge off the paper to try and get the white back. Because it's 'watery', it can also have a mind of its own, so using it can lead to some interesting effects. The clouds in the lower picture on page 184 were achieved by lifting off the wet colour with a dry sponge to show the white of the paper.

The principle behind watercolour painting is that you start from your lightest colour – which can be a light wash or the white of the paper – and then, in layers or further washes, you build up your colours. To start, you draw your scene lightly in pencil with its horizon (which is always parallel to the picture edge) and then start laying down 'washes' over your sketch. If it's an outdoor scene, for instance, you would lay down a wash for the sky first. If you are sketching outdoors, watercolour washes can really bring your sketches to life.

One of the great advantages of watercolours is that they are very small and portable – ideal for doing sketches *in situ*! The sketches overleaf were done on a postcard-sized sketchbook in France. If you would like to see what I mean about just how fabulous watercolour sketches can be, hunt out some of the wonderful watercolour sketches Delacroix did in Morocco.

In the next exercise I am going to introduce you to how easy it is to create a very simple scene of sky and mountains using just two watercolours, a pencil and a medium brush. If you like the exercise, you may want to buy more materials.

Le Gallon D'or C.O. 200

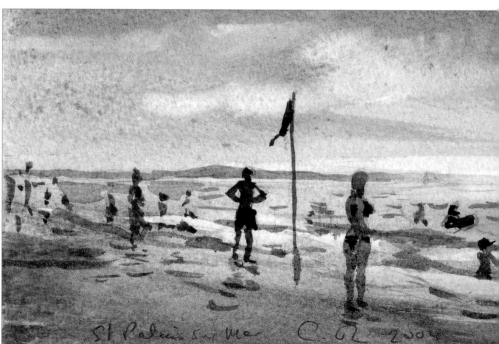

St Palais sur Mer C.O. 2004

Exercise Twenty-four: How to Paint a Watercolour

The idea with watercolours is to build up your painting with what are known as 'washes'. A wash is your colour with water added. The lighter the wash, the less colour/more water there is in it. You should start light and gradually go darker.

The painting we will be doing is of a sky with mountains and a lake. It will show how you can replicate the effects of distance and air using washes. You will need an A4 piece of watercolour paper of about 300g/m^2 (140lb) in weight. This figure refers to the weight of the paper. The reason you need quite thick paper when you are painting in watercolour is so that the moisture doesn't buckle the paper as you are working on it. The surface of watercolour papers differs too. Smooth paper is known as 'hot-pressed'; medium-grain paper is known as 'cold-pressed' or 'not'; rough paper has a grained surface that can give great effects.

For this exercise, apart from your paper, you will need French Ultramarine and Light Red. We mix warm and cool colours together in a wash in watercolours for a reason: what tends to happen is that, as the colour

washes settle, the warm and cool colour pigments in the paint separate into the individual colours in the grain of the paper and give a lovely, shimmering, mottled effect. You will need a medium-sized number 8 brush – a sable if you want to splash out, but a synthetic-mix watercolour brush is fine. You will need a pencil, eraser, something to mix your paint on like a plastic plate and a jar for water. Oh yes, and a hairdryer!

Step one

In the middle of your paper draw a rectangle about 6in x 4in. If you have a postcard handy, draw around this to get a box in the middle of your paper. Around the box is your margin. This is useful if you need to see what a colour is going to look like on the paper before you apply it. Any painting doodles you do in the margin won't be seen as we will crop the image to the postcard size when it's finished.

Next, about two-thirds of the way down the box, draw a horizontal line. This should be parallel with your picture edge. We will call this the 'horizon line'. Now we are going to sketch in the lines of some mountains. Draw lines for the foreground mountains first, then lines for three ranges behind them.

Step two

On your mixing plate or palette, mix up your colour. Take some French Ultramarine and a little Light Red and mix it with a fair amount of water. You will need quite a lot mixed up, but bear in mind that, as you do the painting, you will need to make the wash lighter by adding more water and darker by adding more colour. To start with, though, you want a colour that is similar to the one in this picture. You should have a dulled blue on the palette that looks like a silvery blue on the paper. Try out your colour in the margin of the paper to test it. Have a splash about! This is fun, remember?

Clean your brush in the water (don't worry if the water is not perfectly clear – that's par for the course in watercolours) and wet all the area of the rectangle. Don't worry if you go outside the rectangle as we are going to crop this at the end.

Now add some colour to your brush and start by brushing across the top of the rectangle horizontally from left to right. Keep painting down the picture in this way, but add a bit of water to the colour in your palette as you get halfway down the page to make the colour less intense towards the horizon line. This is what is known as a graduated wash. Carry on with your wash towards

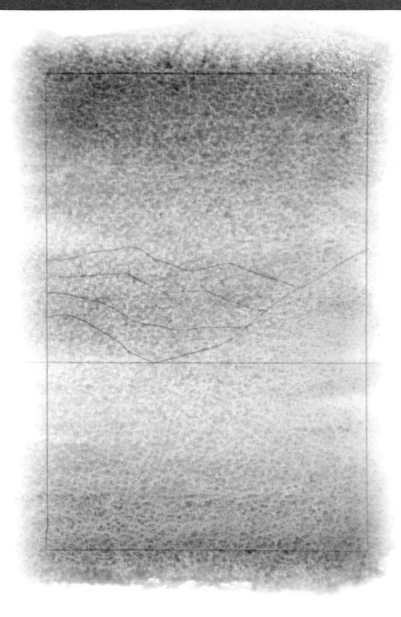

the bottom of the paper, and add a bit more colour again.

Once your paper is filled we need to let it dry. This is where you can go and get a cup of tea – or a hairdryer to speed up the drying process.

TAKE ART

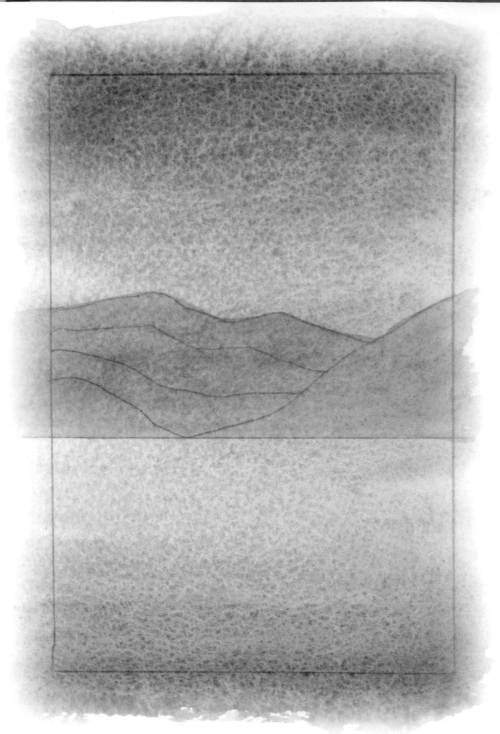

Step three

Touch your paper to check the ground wash is dry. You can now put your second wash on for the distant mountains.

Using a slightly lighter wash of the same colour, fill in all the area of the mountains – areas 1, 2, 3 and 4 – down to the horizon line. Treat it as a single block of colour. Let this dry thoroughly.

Now fill in areas 2, 3 and 4. Let them dry thoroughly.

Now fill in areas 3 and 4. Let them dry thoroughly.

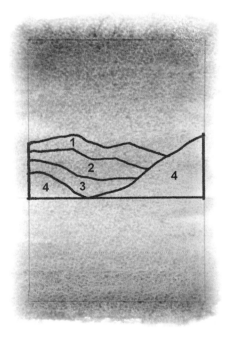

Step four

Now you have painted the three mountain ranges in the distance, and the effects of aerial perspective are making them appear to be receding into the distance, all that remains is to fill in area 4, the foreground mountains. Use the same mix of wash as before, but add a tiny bit more Light Red. This will make the foreground mountains appear closer in the picture because there is more 'warmth' to the colour. What this tells us is that blue makes something recede and warm colours make something closer. When the painting is completely dry, erase your pencil drawing from the scene.

When you're done, admire your work. You have managed to paint a scene that gives a feeling of air and space. If you repeat this exercise straight away, you will find that you are a lot more free in style and you may get better results.

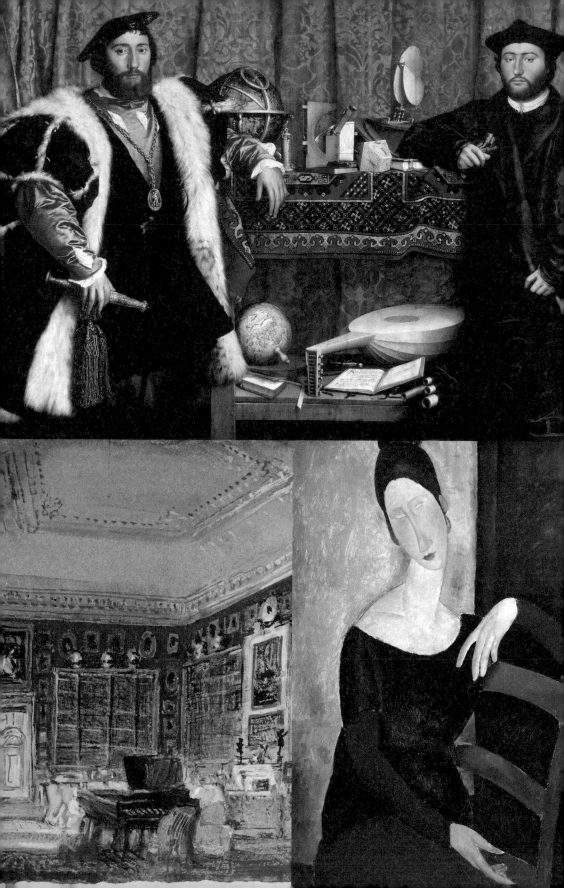

Thinking like an artist (part two)

THINKING LIKE AN ARTIST
(PART TWO)

So now you know the secret of the lost art. After I spent some time with a friend of mine teaching him what we have dealt with in this book, he confessed to me that during the process he had started looking at things differently. He found himself looking at the water running from a tap – it fascinated him and he noticed the light hitting something or other. That was because he had started thinking like an artist. He was keeping an open mind and letting ideas flow in.

Now that you have the knowledge, what are you going to do with it? Are you seeing with an awakened eye?

What do you want to say with your work? What you select and what you leave out will ultimately say a lot about you as a person. Don't forget that your art, if you're pleased with it, may last longer than you – it may even become a family heirloom! As you develop your own critical faculties, you can chuck the ones you think are rubbish and just hang on to the ones you like.

When it comes to inspiration, think of something you love and use this as a starting point. Artists are magpies. Some of the greats were inspired by some of the greats before them, so the art they created becomes like echoes through time. Musicians nick riffs; artists can nick compositions and learn from artists of the past.

Keep a sketchbook and fill it with not only your sketches and doodles but also with any postcards or images that interest you. Many people find painting or drawing therapeutic. It can be a great way to relax and focus on something completely that takes your mind off other matters.

Hopefully, now that you have discovered the lost art, you can think laterally and use the visual knowledge you have gained to go and produce some art of your own.

I want to give you a few final pointers before we part company.

SKETCHES

Just a few words about sketches from artists:

'Perhaps the sketch of a work is so pleasing because everyone can finish it as he chooses.'
EUGENE DELACROIX

'A fine suggestion, a sketch with great feeling, can be as expressive as the most finished product.'
EUGENE DELACROIX

'Do not finish your work too much. An impression is not sufficiently durable for its first freshness to survive a belated search for infinite detail.'
PAUL GAUGIN

Remember when painting or drawing that it's not all about detail: it can be about the *suggestion* of something, with perhaps just a tiny part of the picture displaying detail. Sketches are about capturing something about what you are looking at, that sums it up in the least amount of information. Japanese woodblocks are a great example of 'less is more'.

DEVICES

In David Hockney's book *Secret Knowledge*, the artist rediscovers the lost techniques of the Old Masters. What he finds out is that, despite being able to draw and paint perfectly, a lot of artists used lenses and mirrors to help them create their famous masterpieces. We have already learned that Alberti used glass to capture the effects of perspective. Holbein was another artist who, despite being an excellent draughtsman, drew his sitters on glass using the picture-plane technique to help capture the likenesses of the court – mainly, it is suggested, to save valuable time.

Artists have always used shortcuts to achieve what they want to achieve. I think that it is the final work of art that should be judged, not the means taken to achieve it. Artists have always used whatever tools they have to hand in order to make their jobs easier. It's a means to an end. You have a vision and you do whatever it takes to make that vision a reality.

Today there are more tools then ever at the disposal of the creative mind. We can photograph, trace, project, print out and manipulate digitally to achieve the effect we want. However, most of the artists who used devices had learned how to draw and knew the lost art before

199

they looked to other means to help them. Now that you have read this book, you can too!

Below is an image of Hans Holbein's *The Ambassadors* which hangs in the National Gallery in London. A clue which helps to prove that Holbein may have used optical devices to help him paint appears in the distorted skull in the lower middle half of the painting. When looked at, at a certain angle, the skull appears normal. It is possible that Holbein would have created the distorted skull by

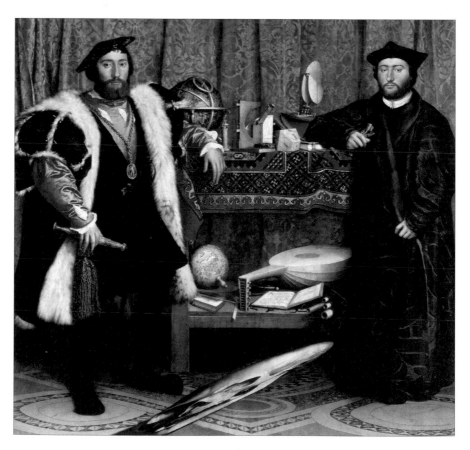

tilting the surface on to which he projected an image of a skull and tracing around it. A similar method is used today, for advertisements that appear on the grass at sports stadia. In reality, when the grass is viewed from the ground, the image/writing appears distorted; but, from a particular camera angle, they appear normal.

STYLISATION

To stylise something is to give it an overall look. If a film or a series of artworks is stylised, everything in it conforms to the style that has been imposed on it.

If you observe the painting overleaf by Modigliani, you can see how the artist elongated his figures, particularly the necks, to give them a stylised look. The sculptor Rodin would deliberately elongate the limbs in the figures of his sculptures to express something about the human body. The stylisation of primitive African art, with its jaggedly carved masks, inspired Picasso.

Early artists stylised things for a number of reasons. The important thing to remember is that they exaggerated by choice and not by mistake. Picasso could draw like an angel before he went on to create art that pushed the boundaries of what had been seen before. Matisse's colourful, decorative later style came out of a

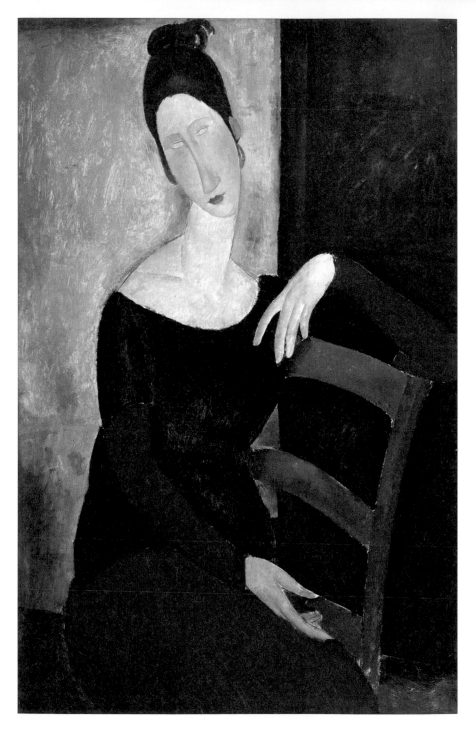

deep understanding of the human figure. Stylisation works if it looks right. It will only look right if you already have the knowledge of what things *should* look like.

ARTISTIC LICENCE

Very often, extremely competent artists begin work knowing what it *should* look like in reality, but paint it how they *want* it to look. They make a conscious decision to change it. This phenomenon is sometimes called artistic licence. When Cezanne painted the scene of Montagne Sainte-Victoire in 1885 (see overleaf, top) he made the mountain bigger than it actually appeared in reality because he wanted to. If you take a photograph from the approximate position of where he would have sat, the mountain is hardly visible in the distance, and there aren't any overhanging bowers.

Canaletto, whose work many people refer to as being 'photographic', painted some scenes of Venetian places. It has since been found out that the places in question would have differed considerably to what is in the actual paintings. Landmarks from two different areas would often be combined in his paintings to look as though they were in one place.

Turner did a series of impressionistic sketches at

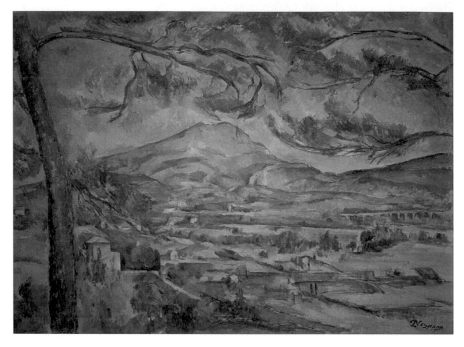

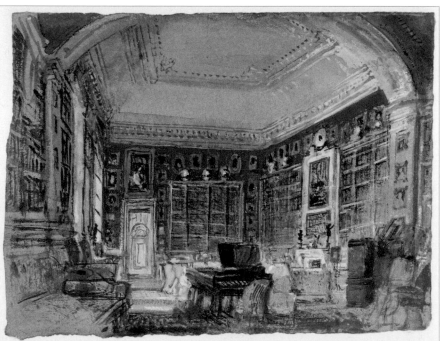

Petworth House in West Sussex, UK. One of them is opposite, below. I visited the house recently and took up position in the room where Turner would have painted this scene. What I noticed straight away was how Turner squashed as much information into his picture as possible. What I saw of the room and what I saw in the painting were two completely different things, and yet Turner had captured everything we need to know about the room using his artistic licence.

It has been recently discovered that the distinctive black and white chequered floors that exist in some of Vermeer's paintings were an addition of his own imagining – floors like this would not have existed in his studio or home. He created the perspective effect by pinning charcoaled string on to the canvas at a vanishing point and twanging it on to the canvas where he wanted to construct the lines! The challenge when using artistic licence is to make what you do look convincing on the paper or canvas. It has to 'work' for you to be happy with it.

PRESENTATION

Any good chef or shop owner will always tell you that presentation is everything. Well, in art it's not *every-thing*, but a good painting can be destroyed by a bad frame and

a bad painting can be made to look a lot better than it actually is with a good choice of frame. Bear this in mind when you have finished your work. If in doubt, go for a plain black wooden frame and you can't go too far wrong! Watercolours and photo-graphs can be enhanced by a 2½ in white mount and a black frame.

When curating an exhibition recently, I also noted that paintings can be enhanced by choosing the right

companions for them. So, just as you would put colours together in a picture, the room or gallery becomes your canvas and the pictures with predominant colours in them can be hung to complement each other. They become almost like colours on a palette. You can also have narrative threads going through the works in an exhibition or your home. So, if one picture is of a horse, the painting next to it could be a picture of a stable or suchlike.

LOOKING AT PAINTINGS

I urge you to go and look at paintings in the flesh. Very often you cannot get a sense of a painting without seeing it in real life. Go and have a look at the work of somebody you admire, stand or sit and look at it like the artist did when he or she had just finished it.

KNOWING WHEN TO FINISH

'Learning to draw never ends.'
HOKUSAI

Every drawing or painting is a journey. It has its own disasters and delights. During the journey there will be moments when the drawing or painting works, but then

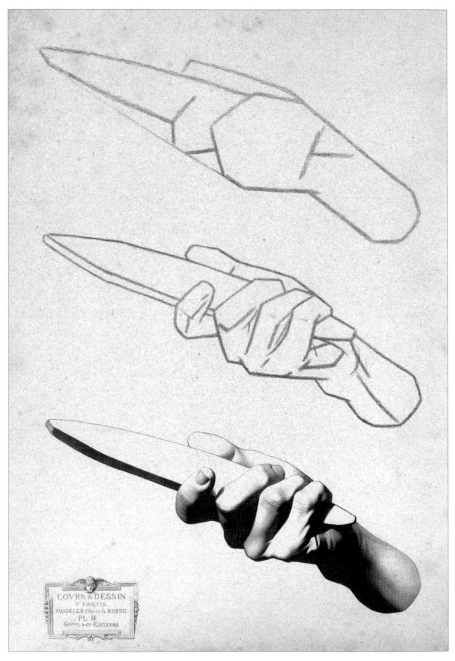

This lithograph is taken from a book called *Cours de Dessin* by Charles Bargue and Jean Léon Gérôme, published around 1868. Artists such as Van Gogh and Picasso used this book to learn the basics of their craft.

you may overwork something and lose the magic. Maybe there is an elusive magic in creating a work of art. You won't find out if you can capture that magic unless you embark on the journey. And sometimes part of the dilemma is knowing when to finish. But you have started the journey now, so don't stop.

People ask me what makes an artist. Well, if somebody says they are an artist and does something that they call 'art', they *are* an artist. It's as simple as that. So, if you decide to be an artist, you can be right now!

I would suggest that you draw a little each day from observation, even if it's only for a couple of minutes, because the more you do it the better you get. I keep abreast of the times and can't help but be influenced by what is going on around me in the media and in galleries, but personally I seek out art that inspires me.

That is why I wrote *Take Art*.

I hope it has inspired *you*.

ARTY FACT

Inspiration can come from many sources. Picasso's first inspiration came in the form of 'churros'. Churros are oil-steeped fritters that malagueños dip into their breakfast drinking chocolate. In the cafés close to his home in Spain, the young Picasso decided that the first shape he wanted to draw was that of a churro, and he would draw them over and over again!

BIBLIOGRAPHY

The New Drawing on the Right Side of the Brain by Betty Edwards

Drawing for the Absolute and Utter Beginner by Claire Watson Garcia

Secret Knowledge: Rediscovering the Lost Techniques of the Old Masters by David Hockney

Awash With Colour by Dermot Cavanagh

Bridgeman's Complete Guide to Drawing from Life by George B. Bridgeman

The Shock of the New by Robert Hughes

FURTHER READING

Drawing Course by Charles Bargue and Jean-Leon Gerome (ed. Gerald Ackerman)

The Sketchbooks of the Romantics by Robert Upstone, Tiger Publishing

Christian's paintings can be viewed online at
www.christianfurr.com

PICTURE CREDITS

Author photograph ©
Gordon Rondelle

All cartoons by Ged Adamson

Page ii *Portrait of Queen
Elizabeth II* by Christian Furr/
© DACS 2008

Page viii Photograph of Richard
Madeley and Judy Finnigan
© Jim Marks

Page 8 *Study for the Sforza
Monument* by Leonardo Da Vinci/
The Royal Collection © 2008,
Her Majesty Queen Elizabeth II

Page 22 Picture of David Beckham
© Solarpix

Page 22 Dove by Pablo Picasso
© Succession Picasso/DACS 2008

Page 64 Picture of Albert Einstein
© Corbis

Page 76 Photograph © Henri
Cartier Bresson/Magnum

Page 78 *La Reproduction Interdite*
by René Magritte © ADAGP,
Paris and DACS, London 2008/
Museum Boijmans van Beuningen,
Rotterdam

Page 80 *Girl with Light* by
Christian Furr/ © DACS 2008

Page 88 Kitchener Poster
© Imperial War museum

Page 89 *Draughtsman Drawing
a Recumbent Woman* by
A Dürer/Albertina, Wien.

Page 104 Line drawing of shoe
© Christian Furr/DACS 2008

Page 108 *Draperie pour une Figure
Assise* by Leonardo Da Vinci/ Paris,
Musée de Louvre/Photo
© RMN/Jean-Gilles Berizzi

Page 110, above: *The Adoration
of the Magi* by Leonardo da
Vinci/Galleria degli Uffizi, Florence,
Italy/Bridgeman Art Library

Page 110, below: *The Concord of
the State* by Rembrandt van Rijn/
Museum Boijmans van Beuningen,
Rotterdam

Page 112 JMW Turner, *Norham
Castle, Sunrise* © Tate, London
2008

Page 115 above, right: *La Jaconde,
Portrait de Mona Lisa* by Leonardo
Da Vinci/ Paris, Musée de